101 TEXTURES
IN GRAPHITE & CHARCOAL

PRACTICAL STEP-BY-STEP DRAWING TECHNIQUES
FOR RENDERING A VARIETY OF SURFACES & TEXTURES

BY STEVEN PEARCE

Walter Foster

Quarto.com • WalterFoster.com

© 2017 Quarto Publishing Group USA Inc.
Artwork © 2017 Steven Pearce, except pages 10–11 and 14–15 © 2013 Steven Pearce;
pages 6–7 ("Paper," "Erasers," "Blender") © WFP; page 6 ("Pencils") © Shutterstock;
and page 8 © 2014 Elizabeth T. Gilbert.

First published in 2017 by Walter Foster Publishing, an imprint of The Quarto Group,
100 Cummings Center, Suite 265D, Beverly, MA 01915, USA.
T (949) 380-7510 **F** (949) 380-7575

Walter Foster Publishing titles are also available at discount for retail, wholesale,
promotional, and bulk purchase. For details, contact the Special Sales Manager by
email at specialsales@quarto.com or by mail at The Quarto Group, Attn: Special
Sales Manager, 100 Cummings Center, Suite 265D, Beverly, MA 01915, USA.

ISBN: 978-1-63322-582-4

Project Editing: Elizabeth T. Gilbert
Page Layout: Ashley Prine, Tandem Books

Printed in the United States
10 9 8

Table of Contents

GETTING STARTED

How to Use This Book

This book includes step-by-step instructions for achieving a wide range of textures with graphite or charcoal.

1. GATHER the tools and materials you need to start drawing. (See pages 6–9.)

2. LEARN the drawing techniques on pages 10–15. Acquainting yourself with the vocabulary and methods for working in graphite and charcoal will help you quickly and easily understand the instructions for replicating each texture.

3. LOCATE your desired texture in the Table of Contents on page 3. The textures are organized in the following six categories:

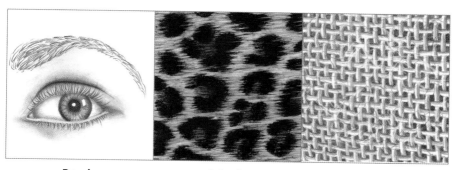

People	Animals	Fabrics & Textiles

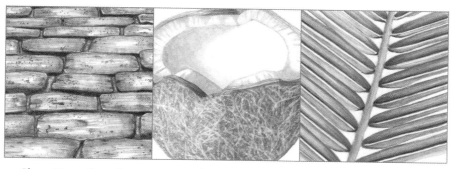

Glass, Stone, Ceramics, Wood & Metal	Foods & Beverages	Nature

4. FOLLOW the step-by-step process outlined to draw your texture.

5. PRACTICE the texture as it appears in the book; then integrate the textures into your own drawings.

Tools & Materials

Paper

Paper has a *tooth*, or texture, that holds graphite and charcoal. Papers with more tooth have a rougher texture and hold more graphite or charcoal, which allows you to create darker values. Rough, textured paper is best when working in charcoal. Smoother paper has less tooth and allows you to create much finer detail when working in graphite. Plan ahead when beginning a new piece, and select paper that lends itself to the textures in your drawing subject.

When you try a paper for the first time, practice and experiment on it. Draw, blend, and erase before starting your final work to see how it will perform. I suggest using only high-quality paper. Buy acid free for your finished pieces, which will resist yellowing over time. When working in graphite, I prefer to use an acid-free Bristol smooth paper or a high-quality 100% cotton rag, hot-pressed watercolor paper. When working in charcoal, I often use toned paper, which allows for dramatic highlights. (For more on toned paper, see page 12–13.)

Pencils

Drawing pencils come in soft and hard grades. Soft-grade pencils range from B, 2B, 3B, up to 9B and 9xxB—extra soft! Hard-grade pencils range from H, 2H, 3H, up to 9H. The higher the number that accompanies the letter, the softer or harder the lead. Between the two grades is the HB pencil, and between H and HB

is the F pencil. Experiment with the different grades to discover which ones you prefer. You will find that you don't need to work with every grade of soft and hard pencil. I have narrowed down my set to just a small number for most of my work, but I keep the others close by in case I need them. Some artists prefer the mechanical drafting (clutch) 2mm pencil rather than traditional wood-encased pencils. A good-quality clutch pencil will last for years and perform very well. The 2mm graphite refill leads come in all the hard and soft grades. When purchasing clutch pencils, make sure you get the sharpener designed for them; it produces a very sharp point for fine-detailed work. You can even save the graphite shavings for later use!

Erasers

There are many different types of erasers available. I primarily use the following:

KNEADED This very versatile eraser can be molded into a fine point, a knife-edge, or a larger flat or rounded surface. It removes graphite gently from the paper, but not as well as vinyl or plastic erasers. Use it in a dabbing motion to pull or lift off graphite from the drawing surface. A kneaded eraser works well for final cleanup.

BLOCK ERASER A plastic block eraser is fairly soft, removes graphite well, and is very easy on your paper. I use it primarily for erasing large areas, but it also works quite well for doing a final cleanup of a finished drawing.

STICK ERASER This is one item that I cannot draw without! Also called "click pencil erasers," these handy tools hold a cylindrical eraser inside. You can use them to erase areas where a larger eraser will not work. Using a utility razor blade, you can trim the tip at an angle or cut a fine point to create thin white lines in graphite. It's like drawing with your eraser! Refills are inexpensive and easy to find.

Blenders

There are many tools available for blending graphite and charcoal. Some you can even find around the house! Never use your finger to blend—it can leave oils on your paper, which will show after applying your medium.

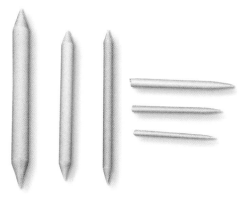

STUMPS These blenders are tightly rolled paper with points on both ends. They come in various sizes and are used to blend large and small areas of graphite, depending on the size of the stump. I keep my old, worn stumps for applying light shades of graphite. You can also use stumps dipped in graphite shavings for drawing or shading.

TORTILLONS These tools are rolled more loosely than stumps. They are hollow and have one pointed end. Tortillons also come in various sizes and can be used to blend smaller areas of graphite.

FACIAL TISSUE This is one of my favorite blending tools. You can wrap it around your finger or roll it into a point. I mostly use it when drawing very smooth surfaces or in portraits to achieve soft skin tones. Make sure you use plain facial tissue, without added moisturizer.

CHAMOIS These cloths are great for blending areas into a soft tone. You can use them for large areas or fold them into a point for smaller areas. I prefer a good-quality natural leather chamois, but a synthetic leather chamois can also yield good results. Cut them into the size that works best for you. When the chamois becomes embedded with graphite, simply throw them into the washer or wash by hand. I usually keep one with graphite on it to create large areas of light shading. To create darker areas of shading, I add graphite shavings to the chamois.

Charcoal

Charcoal is made up of the carbon remains of burnt wood and can produce a rich black with rough, expressive strokes, making it a dramatic alternative to graphite. However, charcoal can also create subtle, velvety blends and fine detail. This medium works best on rougher paper surfaces with plenty of tooth. It also works best with art gum and kneaded erasers. Because charcoal is dusty and dry by nature, it lifts easily and can sometimes be blown off the paper. Use a spray fixative on your finished drawings to ensure that they last.

Charcoal is available in three basic forms, which feel and look very different from one another. It's important to experiment and find the one that suits your personal preferences.

VINE & WILLOW CHARCOAL These lightweight, irregularly-shaped rods of charcoal are made of burnt grapevine and willow tree. Vine produces a gray line, whereas willow produces black.

Vine & Willow Charcoal

Compressed Charcoal Sticks

COMPRESSED CHARCOAL STICKS Compressed charcoal is mixed with a binder, such as gum, which makes it adhere more readily to paper and produces creamier strokes than vine or willow charcoal. Compressed charcoal sticks come in a range of hardnesses, including soft, medium, and hard—or they are listed by number and letter, similar to pencil hardness. You can use the broad side of the stick for large areas of tone, or you can use the end (which you can sharpen with a knife) to create more detailed strokes.

CHARCOAL PENCIL These compressed charcoal tools in a pencil format offer maximum control, allowing you to create fine, precise strokes. Some are wood-encased, so you can sharpen them as you do graphite pencils. However, some charcoal pencils have tips wrapped in paper. To expose more charcoal, simply pull the string to unwrap the paper. Hone the tips with a sandpaper pad or knife.

Charcoal pencil sets usually come with a white "charcoal" pencil (which is usually made of chalk and a binder—not actual charcoal). You can use this pencil with your black charcoal pencils to create dramatic highlights on toned paper.

Charcoal Pencil

White Charcoal Pencil

ARTIST TIP
Charcoal pencil tips break easily, especially when using a handheld or electric sharpener. You may find it easiest to sharpen them with a knife and then hone the tip with a sandpaper pad.

Graphite vs. Charcoal

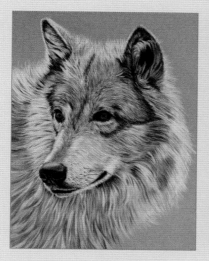 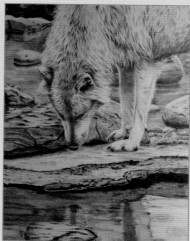

Compare the canine portrait drawn in charcoal and white pencil on toned paper (left) with the canine drawing in graphite (right). Soft, muted, and peaceful, the graphite drawing has a much different mood than the bolder, richer charcoal portrait.

GRAPHITE	CHARCOAL
Works well on smooth to rough papers	Works best on smooth (not glossy), rough, and textured papers
Produces a wide range of gray tones	Produces rich, dark tones and blends into gray tones
White of the paper serves as the highlights	White charcoal on toned paper serves as the highlights
Capable of producing very detailed, controlled linework	Capable of producing very expressive linework

ARTIST TIP

White charcoal (which is actually chalk) comes in different forms, such as compressed sticks and wood-encased pencils. You can use white charcoal either alone on dark-toned paper or alongside regular charcoal to create beautiful highlights and dramatic contrast. Use different pressures to create different values. Like regular charcoal, you can blend white charcoal for a smoother look if desired.

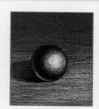

Graphite Techniques

Here are some of the basic graphite techniques I use to create the drawings in this book. Practicing a new technique first will save you from doing a lot of erasing later! There are many more techniques to discover that apply to other styles of drawing, so keep exploring after you have mastered these techniques.

Applying Graphite with a Blender

CHAMOIS Using a chamois is a great way to apply graphite to a large area. Wrap it around your finger and dip it in saved graphite shavings to create a dark tone, or use what may be already on the chamois to apply a lighter tone.

STUMP Stumps are great not only for blending, but also for applying graphite. Use an old stump to apply saved graphite shavings to both large and small areas. You can achieve a range of values depending on the amount of graphite on the stump.

Blending

When you use a blending tool, you move already-applied graphite across the paper, causing the area to appear softer or more solid. I like using a circular motion when blending to achieve a more even result. Here are two examples of drawing techniques blended with a tortillon. On your practice paper, experiment with the various blending tools mentioned in this book.

Burnishing

When you use a soft pencil, the result may appear grainy depending on the tooth of the paper. In some of your drawings, you may desire this look. However, if the area requires a more solid application, simply use a pencil that is a grade or two harder to push, or "burnish," the initial layer of graphite deeper into the tooth of the paper.

Circular Strokes

I use this method often. Simply move the pencil in a continuous, overlapping, and random circular motion. You can use this technique loosely or tightly, as shown in this example. You can leave the circular pattern as is to produce rough textures, or you can blend to create smoother textures.

Erasing

Stick and kneaded erasers are a must. The marks on the left side of this example were created with a stick or click pencil eraser, which can be used for erasing small areas. If you sharpen it, you can "draw" with it. The kneaded eraser is useful for pulling graphite off the paper in a dabbing motion, as shown on the right side.

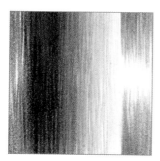

Linear Hatching

In linear hatching, use closely drawn parallel lines for tone or shading. You can gradually make the lines darker or lighter to suggest shadow or light. Draw varying lengths of lines very close and blend for a smooth finish. You can also curve your lines to follow the contour of an object, such as a vase.

Negative Drawing

Use your pencil to draw in the *negative space*—the area around the desired shape—to create the object. In this example, I drew around the vine and leaves, leaving the white of the paper—the *positive space*—as my desired shapes.

Scribbling

You can use random scribbling, either loose or tight, to create a variety of textures such as old leather, rusty metal, rocks, bricks, and more. I even use it for rendering the rough skin of some animals, like elephants. Lightly blend the scribbling to produce different effects.

Stippling

Tap the paper with the tip of a sharp pencil for tiny dots or a duller tip for larger dots, depending on the size you need. Change the appearance by grouping the dots loosely or tightly. You can also use the sharp tip of a used stump or tortillon to create dots that are lighter in tone.

Charcoal Techniques

The following two pages feature the basic charcoal techniques I use to build my textures. Charcoal requires practice to master, so I suggest you try out each technique before attempting the step-by-step textures in this book.

Charcoal Grades

As discussed on page 8, you can choose from a variety of charcoal forms—from vine charcoal sticks to compressed charcoal pencils. For this book, I use wood-encased charcoal pencils, which are graded according to hardness. Depending on the manufacturer, these pencils may be labeled soft or 4B, medium or 2B, hard or HB, and extra hard or 2H. View the difference in richness between these examples.

| 4B (soft) | 2B (medium) | HB (hard) | 2H (extra hard) |

Paper Textures

A variety of textured papers can be used for charcoal drawings. The heavily textured paper (left) can be used for more expressive charcoal drawing, and the smoother, less textured paper (right) can be used for drawings that require finer detail. The paper should not be too smooth or glossy; these surfaces will not hold the charcoal properly. To avoid smudges, apply workable fixative during various stages of the drawing and upon finishing.

Blending

You can employ a variety of blending tools with charcoal, each yielding its own result as demonstrated in this example. Stumps (A) are made of packed paper and create dark blends because they don't pick up much charcoal from the paper's surface; instead, they simply move the charcoal around the paper. A tortillon (B) yields similar results to a stump; but, because it is made of loosely rolled paper, it can have a sharper tip. A chamois (C) is a soft piece of animal skin that produces soft, light tones, as it absorbs some of the charcoal from the paper. Like the chamois, tissue (D) blends softly and lightens the tone as it picks up some of the charcoal off the paper's surface. You can fold both the chamois and tissue to create a narrow tip for blending small areas.

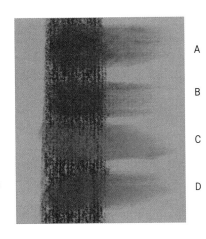

A

B

C

D

Linear Hatching

To create linear hatching, draw parallel lines to tone the paper. Draw them closely for a darker value, and draw them farther apart for a lighter value. You can use tapered strokes, such as when drawing hair, to create a highlighted effect. You can blend over the lines to smooth and soften the tone, but it's generally a good idea to allow at least some of the lines to show through for texture and interest.

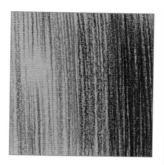

Applying Soft Tones

To apply smooth tone of varying value to your paper, you can use a blender (such as a stump or chamois) with graphite already embedded in its surface. If your blender does not contain enough graphite, you can dab it into charcoal shavings. A chamois is great for smoothly toning large areas, whereas a stump is best for working in small areas.

Negative Drawing

Also called "charcoal reductive" drawing, negative drawing refers to applying charcoal to a portion of the paper and then "drawing" by removing tone. You can remove tone using a kneaded, block, or stick eraser. Apply varying amounts of pressure to achieve different values.

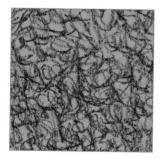

Scribbling

Scribbling, also called "scumbling," is simply random scribbling applied in either a tight or loose manner. This technique is effective for producing rough textures, such as the look of rusted metal.

Stippling

To create the dots that make up stippling, simply tap the paper with the tip of a charcoal pencil. Use a sharp point for small dots and a dull tip for larger dots. (You can also draw larger dots, if needed.) You can group the dots loosely or tightly, and you can make them light or dark depending on your desired result. Stippling effectively adds character to rock, brick, and wood, among many other drawn textures.

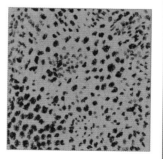

Value

Values are the lights and darks you see in a drawing or photograph. Essentially, values are all the shades, or tones, from black through various shades of gray to white—the paper itself. By using hard and soft pencils, we attempt to create a wide range of these values in our drawing to give depth and an illusion of three-dimensionality to the forms. We use smooth transitions of value from light to dark on curved or round forms such as a ball, and we use mostly abrupt changes in value on forms such as a cube or pyramid.

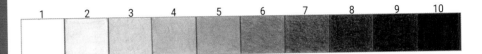

Many artists use a value scale to match the values of a subject to the actual drawing. Using your pencils, make your own value scale, starting with white or the color of the paper. Then add nine other values, ending with the darkest square you can make using the softest pencil that you would normally use in your drawings. Above is a simple value scale that I made.

Remember: Drawing is seeing. Plenty of preparation and thorough study of your subject matter should be done long before you make a mark on the paper. Study your subject and really get a sense of its values. Identify where your darkest and lightest values should be. When using a reference photo, it's best to convert it to a grayscale image so you can get a better idea of the values you can use.

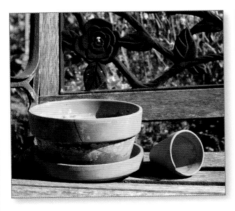

When I was learning to draw, I learned early to "push the darks"—meaning to not be afraid of using the darkest values. You'll need a good amount of contrast between light and dark. A drawing can be done well but look flat or washed out if it lacks darks or contrast.

Shading

When drawing textures, it's important to understand the basics of what happens when the light source hits your subject matter. You need to identify where the darkest and brightest values are by studying the composition thoroughly before you start drawing. This will help you to be more successful when you transfer what you see onto your drawing paper. Use a wide range of values when you shade objects in your composition; the contrast between lights and darks is what gives your drawing three-dimensionality. Let's look at the light and shadow elements of a basic form.

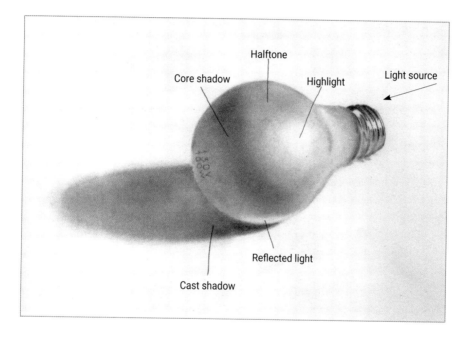

HIGHLIGHT This is the light that shines directly on an object and reflects back into our eyes. This will be the lightest value of the drawing—usually the white of the paper.

CORE SHADOW This the darkest value on the object. It is the part, or side, of the object that separates the light from the shadow areas.

HALFTONE Also referred to as "midtone," this is the area between the highlight and the core shadow. As the shape of the object turns away from the light source, there is a gradation of tones between the highlight and the core shadow.

REFLECTED LIGHT This is light that bounces back onto the shadow area of the object from the surface or other objects in the drawing.

CAST SHADOW This shadow falls from an object onto a nearby surface and away from the light source. Where the object sits or contacts a surface is where the darkest value of the cast shadow is found. As it grows out, the shadow becomes lighter in value.

PEOPLE

1 Aged Skin in Graphite

STEP ONE Using a 4H pencil, lightly draw the basic outline of the face, including the wrinkles of the skin. (The lines shown here are much darker for demonstration purposes.) Then switch to a 4B and draw the darkest values of the deep wrinkles.

STEP TWO Using a 2B and overlapping circular strokes, work from the darkest areas outward to create a gradation along the deep wrinkle shadows. Also, use the 2B pencil to develop additional wrinkles.

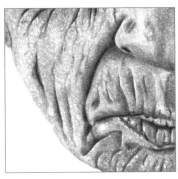

STEP THREE With HB and 2H pencils, continue overlapping circular strokes to create different values of skin. For a more realistic texture, keep the circular strokes a bit loose over the rest of the skin.

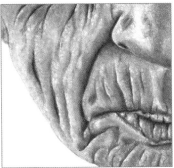

STEP FOUR Lightly blend your strokes to smooth the skin, allowing some of the circular strokes to show through the finished drawing.

2 Smooth Skin in Graphite

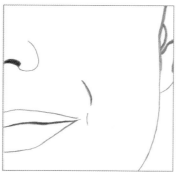

STEP ONE Block in the main areas of the face with light lines. (The lines shown here are much darker for demonstration purposes.) Then establish the darkest values of the drawing using a 4B for the nostril and crease of the lips, followed by a 2B for the crease of the cheek and folds of the ear.

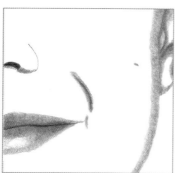

STEP TWO Using an HB and overlapping circular strokes, create the shaded areas of the nose, crease of the cheek, side of the face, and ear. Note that even smooth skin is not perfect; by using overlapping circular strokes, you can avoid making the skin look too plastic.

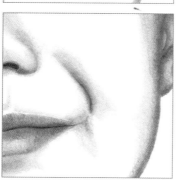

STEP THREE Using a 4H and overlapping circular strokes, create the lightly toned areas of the face. Alternatively, you can use graphite shavings and an old blending stump to work in a circular motion, also creating smooth, light skin tones.

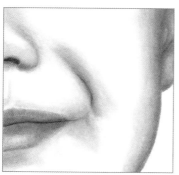

STEP FOUR Blend all areas of the face with a stump to create smooth transitions. Use the tip of a folded tissue to further blend the graphite where needed.

3 Wavy Hair in Graphite

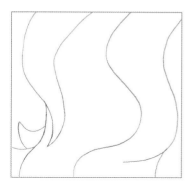

STEP ONE As a guideline, draw the basic flow of the wavy hair and indicate where the darker areas will be. (The lines shown here are dark for demonstration purposes; your lines should be much lighter.) It is helpful to use a reference photo of the type of hair you're drawing, which will help you determine the darks, lights, and general flow.

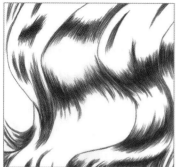

STEP TWO Using a soft pencil, such as a 4B, begin working in the darkest areas. Apply overlapping pencil strokes that follow the basic flow of hair. Using light pressure at the start and lifting at the end of each stroke creates tapered lines that resemble real hair.

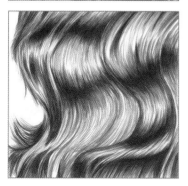

STEP THREE Using 2B and HB pencils, continue applying tapered, overlapping pencil strokes. For the lightest areas of hair, use very few strokes, if any. Notice the contrast in values that occurs within the hair; these differences are necessary to achieve a realistic, three-dimensional appearance.

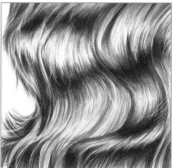

STEP FOUR For more interest and realism, you can use a click pencil eraser that has a trimmed, sharp edge to create some wayward light strands of hair. Using a tortillon or stump, finish with some light blending if needed, especially in the darker areas.

4 Wavy Hair in Charcoal

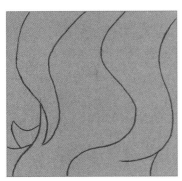

STEP ONE Use a gray-toned charcoal paper for this drawing, or select a different midtone color per your preference. With an extra hard or 2H charcoal pencil and light pressure, create guidelines to indicate the basic flow of the wavy hair. (The lines shown here are dark for demonstration purposes; your lines should be much lighter.) Using a reference photo will help you block in the darks, lights, and general flow.

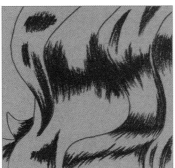

STEP TWO Using a soft charcoal pencil, such as a 3B, start building the darkest areas. Apply overlapping pencil strokes that follow the basic flow of hair. Using light pressure at the start and lifting at the end of each stroke creates tapered lines that resemble real hair.

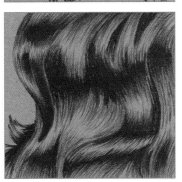

STEP THREE Using a 2H or extra hard charcoal pencil and light lines, continue building tapered, overlapping pencil strokes. Begin each stroke in the darkest areas and lift as you finish each stroke to taper the end. For the lightest areas of hair, use very few strokes, if any. Notice the contrast in values that occurs within the hair; these differences are necessary to achieve a realistic, three-dimensional appearance.

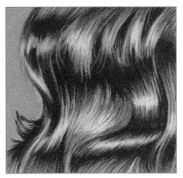

STEP FOUR To create contrast and shine, use a white charcoal pencil to add highlights with long, tapered strokes that follow the waves of the hair. Avoid stroking over the dark charcoal as much as possible.

5 Straight Hair in Graphite

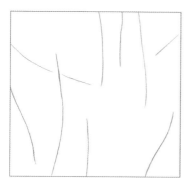

STEP ONE Draw lines showing the basic flow of the straight hair and some of the larger darker areas. (Your lines should be much lighter than the example shown here.) If you're working closely with a reference photo, use lines to block in the main dark areas.

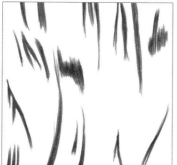

STEP TWO With a soft pencil, such as a 4B, apply some of the darkest values using a series of overlapping strokes that are tapered on both ends. It's a good idea to practice this type of stroke on a separate piece of drawing paper.

STEP THREE Using a 2B for darker values and an HB for lighter values, apply tapered, overlapping strokes that follow the basic flow of hair. Create the darker and lighter values within the hair, which will give it a three-dimensional feel. Remember that it's not necessary to draw every strand of hair. For the highlighted areas, simply leave the white of the paper exposed.

STEP FOUR For more interest and realism, you can use a click pencil eraser that has a trimmed, sharpened edge to create some wayward light strands of hair. Using a tortillon or stump, finish with some light blending if needed, especially in the darker areas.

6 Straight Hair in Charcoal

STEP ONE This example uses tan-toned paper, but you can use the paper color of your choice. Toned paper provides a middle value that will help bring out any white charcoal pencil used for lights and highlights. With a soft charcoal pencil, such as a 3B, draw lines to show the flow of the straight hair. The lines shown here indicate where some of the darker areas of value will be.

STEP TWO With the same soft pencil, use tapered strokes and fill in areas to first establish the darkest values of the drawing. Similar to graphite, establishing the darkest values first can help you better see where the other values are needed.

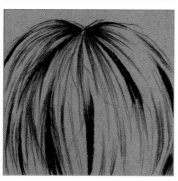

STEP THREE Using a hard-grade charcoal pencil, such as a 2H, use long, tapered strokes to create the strands of hair. Apply more or fewer strokes depending on the darkness, lightness, or thickness of the hair you want to depict.

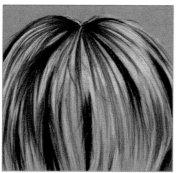

STEP FOUR Using a white charcoal pencil, use tapered strokes to add highlights where needed. Create a few wayward strands of hair using both the 2H charcoal and white charcoal pencils to add more interest. Blend lightly where needed.

7 **Curly Hair** in Graphite

STEP ONE Drawing curly hair can be trickier than wavy or straight hair. Practice drawing a single strand of a curled ribbon, which will help you understand the complex form of curly hair. As a guideline, draw the basic flow of the curly hair, including where the darker areas will be. (The lines shown here are for demonstration purposes; your lines should be much lighter.) It's helpful to use a reference photo as you block in the darks, lights, and general flow of hair.

STEP TWO Using a soft 4B pencil, identify and build the darkest values first. This will help you determine where other values are needed throughout the drawing to develop an effective sense of contrast. Use overlapping, tapered strokes that follow the curves of the hair. Make sure you taper both ends of each stroke. Practice this type of stroke on a separate piece of paper, if necessary.

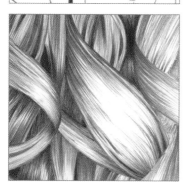

STEP THREE Using 2B and HB pencils, continue to apply tapered, overlapping pencil strokes that following the curves of the hair. For the lightest areas, use very few strokes, if any. Notice the contrast in values that occurs within the hair; these differences are necessary to achieve a realistic, three-dimensional appearance.

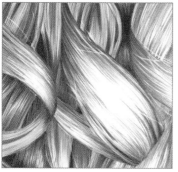

STEP FOUR Use a sharply cut end of a click pencil eraser to "draw" highlighted strands of wayward hair. Lightly blend some area of hair with a tortillon or stump, particularly the darker areas.

23

8 Facial Hair in Graphite

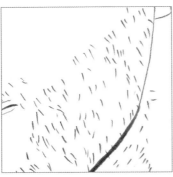

STEP ONE Begin by lightly outlining the face you wish to draw. This example includes a small portion of the mouth and lips. (Refer to page 27 for more on drawing lips.) Using a 4B pencil, identify and build the darkest values, such as the corner of the mouth and jaw line. You can include some of the whiskers at this point, but remember that individual whiskers grow in slightly different directions and do not appear perfectly parallel.

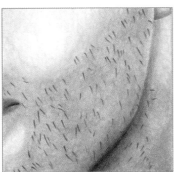

STEP TWO With a 2B and overlapping circular strokes, start in the 4B area and move outward to create a shaded area along the jaw line. Applying overlapping circular strokes and lightly blending will give the skin a realistic look. Then, with an HB and overlapping circular strokes, add light shading to the jaw and neck. Use a 2H for the lighter areas of the cheek and neck, or simply use a stump and graphite to create these areas. Very lightly blend all of the areas with your stump.

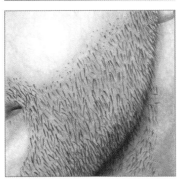

STEP THREE Add more facial hair to the jaw and neck areas at this point, varying the direction of the whiskers. When drawing the whiskers, start by placing the tip of the pencil on the paper; then stroke and lift the pencil at the end of the stroke for a tapered finish. To suggest shorter whiskers along the edge of the beard, use the stippling technique to create dots.

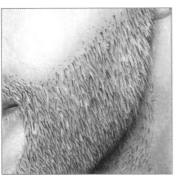

STEP FOUR With a pencil eraser trimmed at a sharp angle, stroke in some highlighted whiskers for a realistic touch.

Nose in Graphite

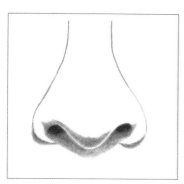

STEP ONE Begin drawing a nose by outlining the basic shape using very light lines (much lighter than shown in this example). Using a 4B and overlapping circular strokes, fill in the darkest areas of value, such as the nostrils. Then use a 2B pencil to shade in the next darkest areas using small, overlapping circular strokes. Lightly blend your strokes, but remember that skin is not perfectly smooth; allowing some of the texture from the strokes to show through creates a more realistic appearance.

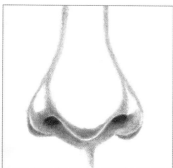

STEP TWO Continue using the 2B to develop other areas of the nose using small, overlapping circular strokes. Leave some thin areas under the nose to show reflected light. Always check your subject's facial features for areas of reflected light; including these subtle changes in value will help create contrast and depth.

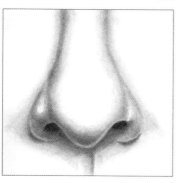

STEP THREE Using an HB pencil, start developing the 2B areas with overlapping circular strokes and move outward to create a gradation for the shadows around the nose. Leave the white of the paper to suggest highlighted areas on the sides and tip of the nose.

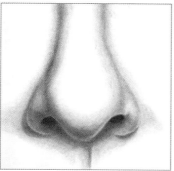

STEP FOUR To finish, apply some light blending, but avoid blending away all the realistic texture. After blending, recover some of the darkest values using 4B or 2B pencils.

10 **Eye** in Graphite

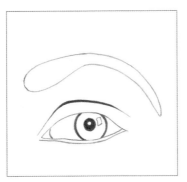

STEP ONE Block in the basic shape of the eye using light lines. (The lines shown here are dark for demonstration purposes; your lines should be much lighter.) Use a 4B pencil to apply the darkest values, including the eyelid and pupil. Delineate the white highlights in the pupil and iris, and remember to keep them free of graphite as you develop the rest of the eye.

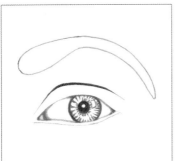

STEP TWO Irises vary from eye to eye. This example uses tapered lines to develop the iris. Notice the break in lines between the inner and outer edges. Remember to work around the reflection. It's important to note that the "white" of the eye is never completely white; it must be shaded depending on how the light hits it. Using HB and 2H pencils, work in small, circular strokes to shade the "white" of the eye.

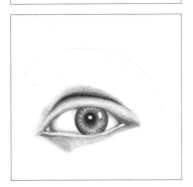

STEP THREE With 2B, HB, and 2H pencils, continue using small, circular strokes to add various values around the eye. Notice the gradation of tones. Using the HB and 2H pencils, create different values within the iris.

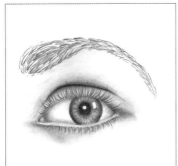

STEP FOUR Lightly blend the areas around the eye, within the white of the eye, and within the iris. As the very last step, use tapered strokes to create the eyelashes and eyebrow. The eyelashes are curved and include differing lengths that grow in slightly different directions. The hairs of the eyebrow also differ in length and vary somewhat in their direction of growth.

11 **Lips** in Graphite

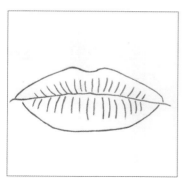

STEP ONE Very lightly draw the basic shape of the lips using a hard-grade pencil, such as a 2H. (The example shown here is drawn darker for demonstration purposes.)

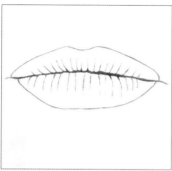

STEP TWO Using a soft-grade pencil, such as a 4B, apply a dark value where the lips come together. Notice how the dark values extend into some of the lines or creases in the upper and lower lips.

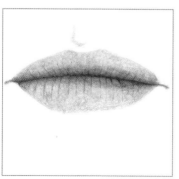

STEP THREE Using a 2B and small, overlapping circular strokes, work your way out from the darkest areas to create a gradation, changing to an HB and then a 2H for the lighter areas. Move along the length of the upper and lower lips.

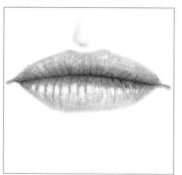

STEP FOUR With a click pencil eraser, remove graphite to create highlights on the lower lip and a few subtle highlights on the upper lip. If desired, lightly blend with a stump or tortillon.

27

ANIMALS

12 Smooth Canine Fur in Charcoal

STEP ONE This example uses a textured, light-colored charcoal paper. Using a soft 3B charcoal pencil, establish the darkest values first. Use short, tapered strokes for the smooth fur. A soft charcoal pencil dulls quickly on textured paper; instead of constantly sharpening the pencil, turn the pencil slightly as you work to yield finer lines. (You can use this technique with graphite tips as well.)

STEP TWO Using an HB charcoal pencil, begin your strokes in the darkest areas and taper the ends. Vary the direction of some strokes slightly for realism, as fur never grows perfectly parallel.

STEP THREE Continue developing the fur with light, short, and tapered strokes of 2H charcoal pencil.

STEP FOUR If desired, you can add tapered strokes of white charcoal pencil to further bring out highlights.

13 Curly Canine Fur in Graphite

STEP ONE Some dog breeds have curly hair resembling that of a human, so the drawing technique is very similar. This example shows the curly fur of an Irish Water Spaniel. Begin by drawing the basic shapes of the curls using a 4H pencil. (The lines shown here are dark for demonstration purposes; your lines should be much lighter.)

STEP TWO Then establish the darkest areas of value using a 4B pencil.

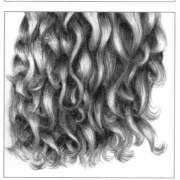

STEP THREE With 2B and HB pencils, use tapered strokes to create progressively lighter fur. Allow the white of the paper to serve as the highlighted areas of the curls. Remember that you don't need to draw every strand of fur.

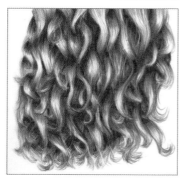

STEP FOUR To finish, lightly blend your strokes with a tortillon or small stump. With a click pencil eraser trimmed at sharp angle, pull out some wayward fur and enhance highlights as needed.

14 Coarse Canine Fur in Graphite

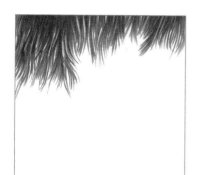

STEP ONE This example shows the coarse fur of a wirehaired dog breed. Begin by using a 4B pencil to build the darkest areas with bold strokes. As you draw, leave some white of the paper exposed to indicate light hairs mixed with dark hairs. Randomly applied strokes will contribute to the realistic, wiry look. (When working on a larger drawing at this stage, consider lightly outlining areas of dark and light values to serve as guidelines.)

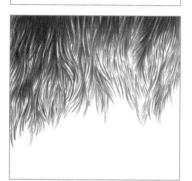

STEP TWO Using a 2B or HB pencil, continue applying the same bold, random strokes as in Step One. Within the lighter areas of the coat, allow more of the white paper to come through for realistic highlights. Taper each stroke at the end for a realistic touch.

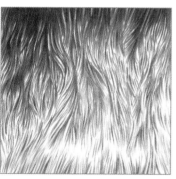

STEP THREE Switch to a harder, lighter pencil for more highlighted areas as needed. In this example, see how using few strokes (or none at all) allows more of the white of the paper to show through, creating the illusion of highlights.

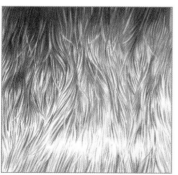

STEP FOUR To finish, use light blending to tone down some of the lighter individual hairs in the darker area. Using a click pencil eraser trimmed at a sharp angle, create additional strands of wayward hairs. You can use a pencil to shade one side of these highlighted hairs for more depth and realism.

15 Canine Nose in Graphite

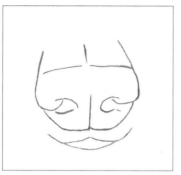

STEP ONE Canine noses have a basic shape, but they can vary a bit depending on the breed and size of the dog. Also, noses can range from very dark to very light in color. To begin, draw the basic shape of the nose lightly with a 2H or 4H pencil. (The lines shown here are dark for demonstration purposes; your lines should be much lighter.)

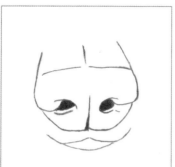

STEP TWO Now apply the darkest values of the nose using a 4B pencil. Establishing the darkest values first will help you better judge the remaining values.

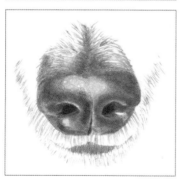

STEP THREE Use a 2B and small, overlapping strokes to build outward from the darkest values of the nose, switching to an HB to create a gradation. Use a 4H for the highlighted areas of the nose. To create the fur around the nose and mouth, use HB and 2H pencils.

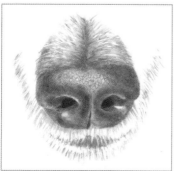

STEP FOUR All canine noses share a distinct texture. For this nose, use a 2H pencil to draw an irregular pattern in the highlighted area and blend lightly. Use a stick eraser cut at a sharp angle to create lighter whiskers around the mouth.

16 Canine Eye in Graphite

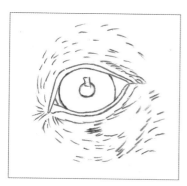

STEP ONE Very lightly draw out the outline of the eye and the basic direction of the surrounding fine fur. Delineate the reflection of light so you can keep it free of tone. (Always include a reflection to give the final drawing more depth and realism.) Canine eyes vary depending upon the breed, so it's a good idea to study a high-quality reference photo as you draw.

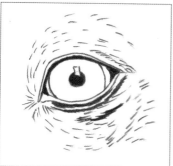

STEP TWO Establish your darkest values using a 4B or 6B pencil, which will help you set up a drawing with a good amount of contrast.

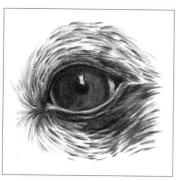

STEP THREE You'll notice that the edge of the iris is darker, becoming lighter as you move toward the pupil. Replicating this will give the eye depth and dimension. Create the edge using small, overlapping circular strokes and a 2B, switching to an HB for the lighter areas and allowing the white of the paper to serve as the reflection. Shade the small amount of the "white" of the eye that shows with a 2H pencil. Use this pencil to shade the upper and lower lids as well, and build the fur around the eye with 2H and 2B pencils.

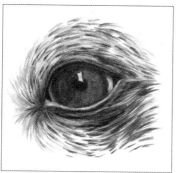

STEP FOUR If desired, lightly blend with a small stump or tortillon. Try not to over-blend, which can soften some of the sharper, finer lines that should remain crisp. Use a stick pencil eraser with the tip trimmed at an angle to create any subtle, fine reflective areas in the eye.

17 Cat Eye in Graphite

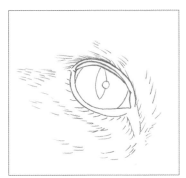

STEP ONE Using very light pressure, outline the structures of the cat eye and sketch in some lines showing the direction of the fur around it. (The lines shown here are dark for demonstration purposes; your lines should be much lighter.)

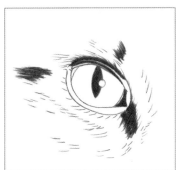

STEP TWO With a 4B pencil, fill in the darkest areas of value in the drawing. With the darkest value established and the white of the paper as a guide, you'll have a better sense of where the other values belong. Use overlapping, tapered strokes to create the fur around the eye.

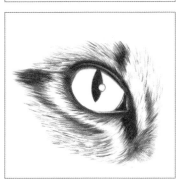

STEP THREE Now use a 2B and an HB to develop the structures around the eye, creating fur with tapered strokes. Remember that it's not necessary to draw each strand of fur. Allow the white of the paper to serve as highlights within the fur.

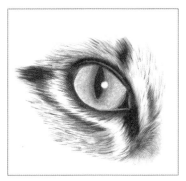

STEP FOUR Using 2H and 4H pencils, apply overlapping circular strokes starting with the darker area around the iris (2H) and moving in toward to the lighter area (4H). Lightly blend this area with a tortillon. To finish, lightly blend the areas around the eye and fur using a tortillon or small stump.

18 **Short Cat Fur** in Graphite

STEP ONE In this example of short cat fur, the stripes can help you understand the techniques of creating both light and dark fur. When drawing an animal with stripes, it's a good idea to start by lightly outline the various values, following the curvature of the animal.

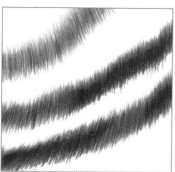

STEP TWO As an example of how the stripes can be of different values, two of the stripes are shown as darker in value and the third (top) as lighter. For the darker stripes, use a 4B pencil; for the lighter stripe, use a 2B. Apply overlapping, tapered strokes so that both sides of the stripe are showing tapered points.

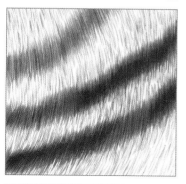

STEP THREE Continue adding tapered strokes between the stripes with a lighter pencil, such as an HB. Make the strokes dense in dark areas and sparse for light areas. Remember that it's not necessary to draw each individual strand of fur; use just enough to differentiate the dark and light values. Vary the direction of some strokes slightly to give the fur a more realistic look.

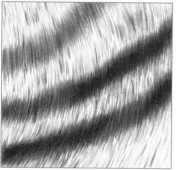

STEP FOUR To finish, add random, dark, and thin strokes to the fur for more depth. Very minimally blend with a stump or tortillon. Use your pencil eraser or a kneaded eraser to enhance or create more highlighted areas for more contrast.

19 Long Cat Fur in Charcoal

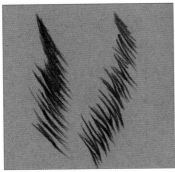

STEP ONE Using a soft charcoal pencil, such as a 3B, begin by drawing the areas of dark value. Long cat fur can appear to be more tangled, so not all of the strokes should be perfectly parallel to each other. Notice that most of the tapered strokes form a narrow "V" shape, which indicates the deeper areas of shadow within the fur.

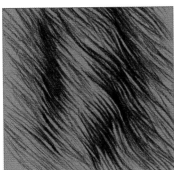

STEP TWO Using a hard-grade charcoal pencil, or simply lightening the pressure of your pencil, start in the darker areas and create long, tapered strokes. Slightly curving most of the strokes gives the fur a wavy flow. Remember that it's not necessary to draw each individual strand of fur; suggest the appearance of fur using just a few light and dark strokes.

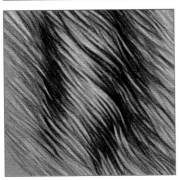

STEP THREE For more contrast and detail, use a white charcoal pencil to fill in areas between some of the strokes, which will lighten and highlight the fur. Again, use strokes that taper at each end.

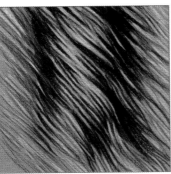

STEP FOUR To finish, return to darken areas with a soft charcoal pencil for more contrast and depth. Using a stump, lightly blend areas that need a softer look, or darken some areas by pushing the charcoal into the tooth of the paper for more contrast.

20 Horse Mane in Graphite

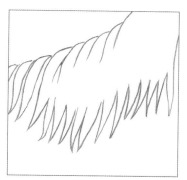

STEP ONE Begin by outlining the horse mane using very light lines. The outline can be a simple, rough indication of the mane's general shape and location. (The lines shown here are dark for demonstration purposes; your lines should be much lighter.)

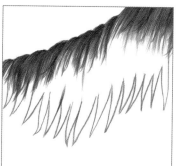

STEP TWO With a 4B pencil, apply long, tapering strokes closely together to build up the areas of darkest value. Notice that not all of the hair is flowing in the same direction; some are appear slightly windblown for a realistic touch. Don't be shy about using dark values, as they will allow your drawing to "pop" more than moderate values. In most cases, the less contrast used, the flatter and less compelling your drawing will be.

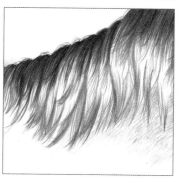

STEP THREE Continue with a lighter (harder) pencil, such as an HB, to draw more of the mane. Use long strokes and tapered ends. Remember not to draw every single hair, and always allow some white of the paper to indicate highlights.

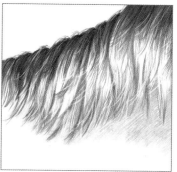

STEP FOUR Finish with light blending, and use a trimmed pencil eraser to pull out some final highlights.

21 Horse Mane in Charcoal

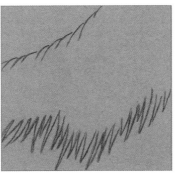

STEP ONE Begin by lightly outlining the general shape of the horse mane. To create a lighter line than shown here (as you would do for a light-colored mane), use a hard-grade charcoal or even a light graphite pencil for this step.

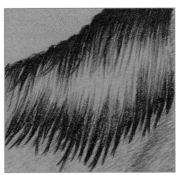

STEP TWO The techniques involved in drawing a horse mane resemble those used to create human hair. Using a soft charcoal pencil, such as B or HB, establish the darkest value first. Then use a harder charcoal pencil to create the slightly lighter, finer hairs. Begin your strokes in the dark areas, and taper them at the ends. Use short, light strokes to indicate the coat of the horse.

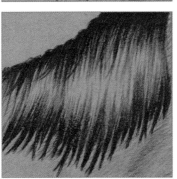

STEP THREE The texture of charcoal paper can be rough, which causes some of the paper to show through a stroke. To cover these bits of paper, you can blend with a stump. However, sometimes the textured strokes of charcoal paper produce a desirable effect.

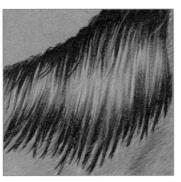

STEP FOUR At this point, you can use a white charcoal pencil to bring out even more highlights and lighter individual hairs.

22 Horse Coat in Graphite

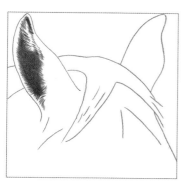

STEP ONE This texture shows a close-up example of a short, smooth horse coat. When drawing on a smaller scale, you may find it necessary to include less detail and simply indicate the lights and darks of the horse's anatomy, as the fine details of a horse's coat would be indistinguishable from a distance. For this texture, outline the basic structures of the horse with a 2H or 4H pencil. Use tapered strokes as indications of hair in the ear.

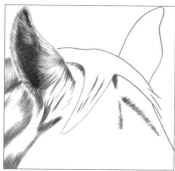

STEP TWO Using a 2B pencil, fill in the light values using short, tapered strokes. As you stroke, be sure to follow the curves of the anatomy and note any other ways that fine hair grows on a horse.

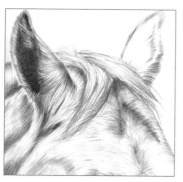

STEP THREE Using an HB pencil, complete the lighter values using the same tapered strokes. Keep the strokes sparse in highlights and lighter areas of the horse.

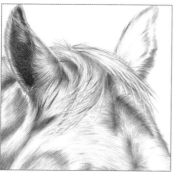

STEP FOUR Using a stump or tortillon, blend your strokes to give the hair a smooth appearance. Then use a click eraser with the tip trimmed at a sharp angle (roughly 45 degrees) to pull out highlights. To finish, darken any areas that lost value when blending.

23 Elephant Skin in Graphite

STEP ONE If you have recently visited the elephants at your local zoo, you may have noticed how wrinkled their skin appears. Drawing their skin is similar to drawing wrinkled human skin. Using a 4B pencil, begin by drawing the wrinkles.

STEP TWO Continue using the 4B pencil for the darkest values of the drawing, working with overlapping, circular strokes. Use tapering strokes for more dimension, but feel free to be loose and irregular, which will add to the sense of realism.

STEP THREE Using a 2B pencil, work outward from the darkest areas to create a subtle gradation. As you stroke, use less and less pressure on the 2B pencil to create lighter values. Again, use the overlapping circular strokes, and don't try to be perfect. At this point, draw additional, lighter wrinkle lines.

STEP FOUR Now lightly blend your strokes. Some of the darkest areas may need another layer of graphite after blending to recover the darkest values for good contrast. To finish, use a kneaded eraser to bring out more highlights.

24 Snake Skin in Graphite

STEP ONE This example is just one of many different varieties of snake patterns. The scales are arranged in an orderly fashion, so it is a good idea to practice the pattern on a separate piece of drawing paper. To begin, use a 2H pencil (or lighter) to draw the outline. (The lines shown here are dark for demonstration purposes; your lines should be much lighter.)

STEP TWO Use a 4B pencil to fill in the darkest values of the pattern, as shown.

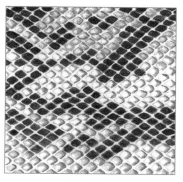

STEP THREE With an HB pencil, add thin shadowing to the outside edge of the remaining scales. Then use a 2H to add tone to the scales, applying a little more on the outside scales and less on the ones in the middle for dimension. Also, leave the centers of some of the individual scales a little lighter to create highlights and a sense of depth.

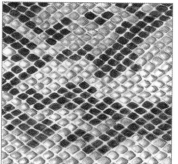

STEP FOUR To finish, lightly blend each scale with a small stump or tortillon. Then use a kneaded eraser molded to a point to slightly lighten some of the dark (4B) scales. After blending, revisit some areas as needed with the pencils to add more tone or contrast. Use a kneaded eraser to pull out more highlights.

25 **Feather** in Graphite

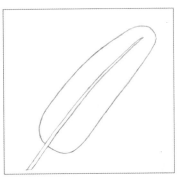

STEP ONE Outline the basic shape of the feather using light lines. (The lines shown here are dark for demonstration purposes; your lines should be much lighter.) Note that feathers vary in shape between birds, as well as their location on a bird's body.

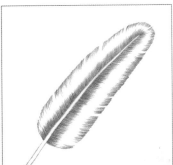

STEP TWO With a sharp 2B pencil, start from the shaft and stroke outward to create tapered lines—similar to drawing hair or fur. In this case, try to make your strokes as parallel to each other as possible. Then create tapered marks from the outside edge of the feather inward, moving toward the shaft. For a realistic touch, create several slight "V" shapes along the edge to suggest where individual barbs have separated.

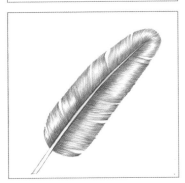

STEP THREE With a sharp 2H pencil, follow the slight curves of the feather's barbs as you add more tapered, parallel strokes between the strokes previously applied with the 2B pencil. This will give the feather a highlighted look.

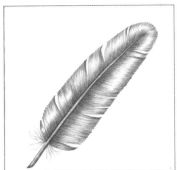

STEP FOUR With a 2B pencil, darken the two sides along the shaft of the feather and to the bottom of the quill. With a 2H pencil, add some tone along the shaft and the quill; then lightly blend to give the shaft and quill a more realistic, dimensional appearance. Not much blending, if any, is needed for the vane of the feather. To finish, use an HB pencil to create some of the "after feather" near the quill base.

Leopard in Charcoal

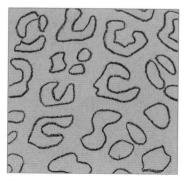

STEP ONE In this charcoal drawing example, tan-toned charcoal paper helps this texture closely resemble leopard skin. Begin by outlining the leopard's spots using a 2H or an extra-hard charcoal pencil. (The lines shown here are dark for demonstration purposes; your lines should be much lighter.) You'll notice that some of the spots are actually various shapes, with some resembling the letters "C" and "U."

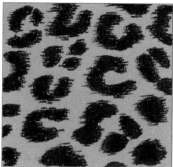

STEP TWO Using a soft 3B charcoal pencil, fill in the spots using strokes that indicate the direction of fur growth. Charcoal paper is generally a rough surface with plenty of "tooth," so some of the paper will show through the strokes for a broken (but often desirable) appearance.

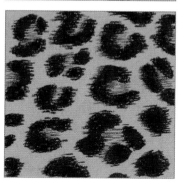

STEP THREE With an HB charcoal pencil, fill in the centers of the spots with tapered strokes so that they appear darker than the surrounding fur. With a 2H or extra-hard charcoal pencil, create light, tapered strokes to indicate the fur around the spots. You don't need many strokes to indicate the fur; you'll want plenty of paper to show through.

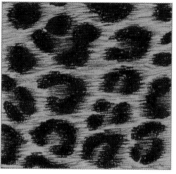

STEP FOUR Next, lightly blend the spots and add some highlights using a white charcoal pencil and tapered strokes. For a realistic look, remember to vary the strokes of fur rather than make them perfectly parallel.

27 Zebra in Graphite

STEP ONE A zebra's short coat is similar to that of a horse, but the pattern is distinct. Begin by outlining the black-and-white striped pattern using light lines. (The lines shown here are dark for demonstration purposes; your lines should be much lighter.)

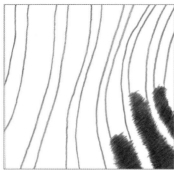

STEP TWO The coat shows highlights and shadowed areas when viewed in sunlight, so start with the darkest values first. Use a 4B pencil to apply hatch marks with tapered ends. Establishing the darkest areas first will help you better judge the remaining values.

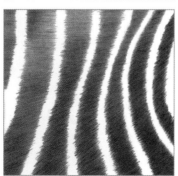

STEP THREE Then use a 2B pencil to hatch within the lighter stripes, switching to HB and 2H pencils for the lighter areas. Few marks, if any, are needed in areas of highlight.

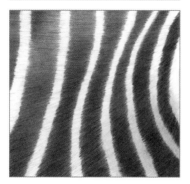

STEP FOUR Finish by lightly blending where needed, using the stump or tortillon to add subtle tone between the black stripes.

28 Zebra in Charcoal

STEP ONE The zebra's very short coat has a striped pattern that is unique to each individual. As with other animals with short coats, the pattern follows the form of the body. Begin by outlining the pattern of stripes using a 2H charcoal pencil.

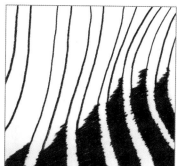

STEP TWO Then use a 3B charcoal pencil to establish the darkest values, using hatch marks to indicate the individual hairs. Having the darks and lights (the white of the paper) in place will help you effectively determine any remaining values.

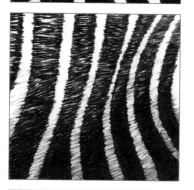

STEP THREE Use progressively lighter (harder) charcoal pencils, such as B to 2H, to gradually lighten the stripes by stroking from the shadow into the highlighted areas. You can also leave more space between the hatch marks as you move toward the highlighted areas. For more depth, further darken the white areas in shadow by lightly indicating hairs with hatch marks.

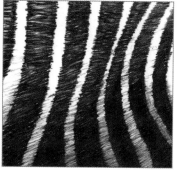

STEP FOUR To finish, lightly blend the stripes, particularly within the areas of shadow.

FABRICS & TEXTILES

29 **Burlap** in Graphite

STEP ONE Using a hard-grade pencil, such as a 2B, lightly draw a basket weave pattern. The individual threads of the weave vary in thickness, so there is no need to be perfect.

STEP TWO You can leave the background as the white of the paper if desired. In this example, however, a 2B pencil over the background provides more contrast.

STEP THREE With an HB pencil, apply simple hatch marks to just one side of each horizontal and vertical thread. This gives the appearance of light hitting it from one direction, creating depth.

STEP FOUR If desired, lightly blend the threads with a small, fine-tipped tortillon, but avoid blending away the individual hatch marks. Upon observing a small area of burlap, you'll notice many fine fibers coming off the threads. To suggest this, use an HB pencil to create darker fibers and a stick pencil eraser with a sharply trimmed point to create lighter fibers.

30 **Chunky Wool** in Graphite

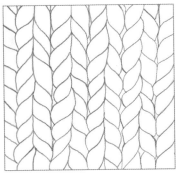

STEP ONE Begin drawing this thick wool by lightly indicating the pattern of your knitted object. (The lines shown here are dark for demonstration purposes; your lines should be much lighter.)

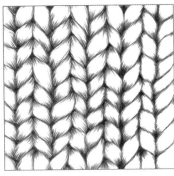

STEP TWO Using a 4B pencil, fill in the areas of shadow. Switch to a 2B pencil and draw outward from the shadows, creating dark, tapered strands of wool. Follow the curves in the yarn, but avoid being too perfect; chunky wool yard often looks loose and tangled up close.

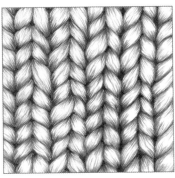

STEP THREE Using a 2H pencil, create lighter stands in the yarn. Again, start your strokes in the darker areas and work outward, leaving the ends of the shorter strokes tapered. Avoid drawing too many strands in the highlighted areas of the yarn. Let the white of the paper come through to give depth to the drawing.

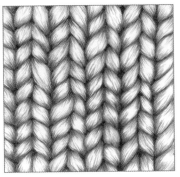

STEP FOUR Lightly blend with a stump or tortillon, working mainly in the darkest areas to smooth transitions from shadow to light. Use the graphite on the stump or tortillon to add soft, light tone to other areas as needed.

Tweed in Graphite

STEP ONE Tweed is a thick, woven fabric used primarily in suits and coats. This sturdy material is also available in a variety of patterns. This example features a "V" or herringbone pattern. Outline the basic flow of the pattern, noting that the lines shown here are much darker for demonstration purposes.

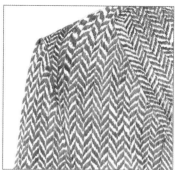

STEP TWO Using a 2B or 4B pencil, roughly draw the individual "V" pattern to represent the thick, darker woven threads of the fabric. Apply this pattern following the basic curves of the coat.

STEP THREE With a lighter 2H pencil, draw a few lines in between the thicker, darker strokes to indicate lighter threads of fabric.

STEP FOUR Using a 4B pencil, create the dark areas of shadow around the coat, lapel, and arm. Lightly blend the shadowed areas and the coat's pattern.

32 **Denim** in Graphite

STEP ONE This example shows a fairly simple method for drawing denim fabric with a basic seam. Begin by drawing a light outline of your subject. (The lines shown here are much darker for demonstration purposes.)

STEP TWO Use a soft, dark pencil (such as 4B) to lay in long, tapered strokes following the slight curve of the seam. Use your arm—not just your wrist—for these long strokes. Allow some white of the paper to show through between the strokes, especially in the lightest areas. For the seam, create high (light) and low (dark) spots that occur as a result of the stitching. In older denim, the high areas and folds are lighter, appearing worn. Create depth by adding the darkest areas—along the fold of the seam, where the stitching penetrates the fabric, and along one side of each stitch.

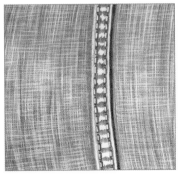

STEP THREE There are two ways to create the cross-stitching on the denim fabric. You can use perpendicular strokes with the 4B pencil over the strokes already applied, or—as in this example—perpendicular strokes using a click eraser cut at a sharp angle to create thin, light lines that resemble light threads. You'll have to cut the eraser often to maintain sharp, light lines.

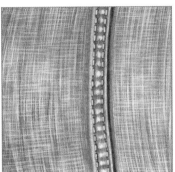

STEP FOUR To finish, use a small stump or tortillon to blend along the sides of the seam and stitching, along with the darker areas between the stitching. Use the white of the paper to represent the lightest areas of the seam and fold.

33 Silk in Graphite

STEP ONE Silk has a very smooth texture that reflects light, which makes it important to pay careful attention to highlights and areas of reflected light. Outline the basic shape of the fabric with light lines (much lighter than shown in this example). You can add more guidelines as the drawing progresses.

STEP TWO Now add the darkest values using 6B or 4B pencils. Apply small, light, circular strokes, covering as much of the paper as you can. To soften some of the hard edges, lighten your pencil pressure as you move away.

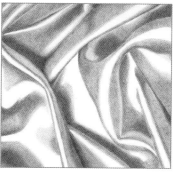

STEP THREE Using 2B, HB, and 2H pencils, continue creating folds of silk using values of light and dark, working in small, overlapping, circular strokes. Again, this fabric can be quite reflective, so use the white of the paper to represent highlights. For light values, use a harder pencil. It's a good idea to test the range of values you can create with each pencil hardness on a separate sheet of drawing paper.

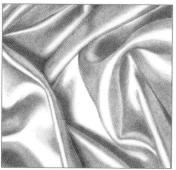

STEP FOUR Use a small stump to blend along the reflected light of the folds and a larger stump to blend the shadowed areas. As you move outward, create light shadows using the graphite-coated stump. Because blending removes some of the graphite, create more contrast by touching up with more graphite where needed. Use a hard 4H pencil to push the graphite deeper into the paper, creating a dark, even tone.

34 Lace in Graphite

STEP ONE Because this black lace requires a dark tone, use a 4B pencil throughout the drawing. Begin by working out the basic outline on a separate sheet of paper; then transfer it to your drawing paper. To transfer a drawing, coat the back of the paper with graphite and place it over a clean sheet of drawing paper. (You can also use graphite transfer paper.) As you trace over the drawing, the lines will transfer to the clean paper below, revealing a light outline.

STEP TWO If you look at lace closely, you'll notice the basic outline is made up of tiny threads woven together. Continuing with the 4B pencil, use very small, circular, overlapping strokes to thicken the lines for a woven look.

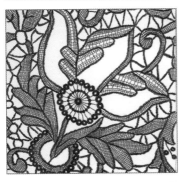

STEP THREE To create the fine webbing, use a sharp, fine point to apply criss-crossing strokes over areas of the design. In some areas, follow the curves of the design with your strokes. Within the flower petals, use a gap in the center of the criss-crossing pattern for interest. Fill in the dots and small "donuts" of the design.

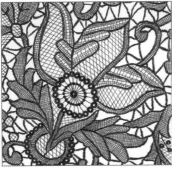

STEP FOUR For more contrast and variety, use a larger criss-cross design in some areas. Keep your strokes clean and avoid blending as you create this fine, delicate subject.

Leather in Graphite

STEP ONE Leather comes in a variety of textures, from smooth to rough. This example of rough leather includes a seam and stitches. Begin by creating an outline with light strokes. (The lines shown appear darker for demonstration purposes.)

STEP TWO Using different hardnesses of pencil (4B, 2B, and 2H), create the small, irregular shapes that resemble puzzle pieces. Place them close together, with just a small gap between them. For the highlighted areas, use light pressure and a 2H pencil. Don't worry about creating perfect strokes; simply use small, overlapping, circular strokes and scribbling to give the shapes a bit of rough texture.

STEP THREE Use a 4H pencil and light, vertical strokes to coat the drawing, avoiding the stitches and areas of highlight. This will add tone overall and darken the areas between the shapes. With a 2H pencil, add shadow to the top and bottom of each stitch, leaving the center of each free of tone to represent a highlight. Using a 2B pencil, shadow the top and bottom of each stitch, leaving the middle highlighted. Then add a dark, thin shadow to the top and right side of each stitch and to the right side of the long seam for depth.

STEP FOUR Using a stump, lightly blend around the seam and over the leather to even out the tone and smooth out pencil strokes where needed. Also, lightly blend both sides of the highlighted area (down the center) to give it more of a gradual tone.

36 **Leather** in Charcoal

STEP ONE In this example of rough leather in charcoal, begin with a gray- or brown-toned paper. Use light strokes to outline the seam and stitches. (The lines shown here are darker for demonstration purposes.)

STEP TWO This texture calls for B and HB charcoal pencil for the darkest values, plus an extra-hard charcoal pencil to define the irregular shapes within the highlighted section down the center. The irregular shapes should resemble puzzle pieces separated by small gaps. Keep your strokes loose and allow the tooth of the charcoal paper to show through, especially in the lightest areas.

STEP THREE To tone down the spaces between the irregular shapes, use an extra-hard charcoal pencil. Coat the leather with vertical, closely placed strokes, working around the seam, stitches, and highlighted areas.

STEP FOUR To finish, use the extra-hard charcoal pencil to shadow the ends of each stitch, and use it to tone the seam. Lightly blend areas with a stump to deepen tone where desired, pushing the charcoal deeper into the tooth of the paper.

37 **Straw Hat** in Charcoal

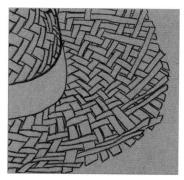

STEP ONE Tan charcoal paper is an ideal choice for this subject matter. As you begin to draw, note that straw hats are similar in structure to woven baskets. Lightly sketch the outlines with pencil, followed by charcoal pencil. Choose a hard charcoal pencil, such as a 2H, to create thin, light lines.

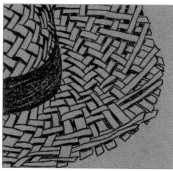

STEP TWO Switch to a softer charcoal pencil, such as a 3B, to fill in the shadows around the weaves. Next, with the same pencil, use long strokes to follow the curvature of the hat's band.

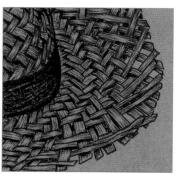

STEP THREE Return to the 2H charcoal pencil to create the grain of the weaves with thin lines. Between each stroke, rotate the tip of the pencil so you are always working with a sharp end.

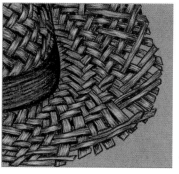

STEP FOUR To finish, add some highlights to the drawing by applying strokes of a white charcoal pencil over the raised parts of the weaves and along the band.

38 **Knitting** in Graphite

STEP ONE This example of a knitting design shows one of many possible techniques. Begin by outlining the pattern with light strokes; you can always recover or darken the lines as the drawing progresses, if needed.

STEP TWO Using a 4B pencil, fill in the darkest values of the drawing to create a sense of contrast. Use the darks as a gauge for determining subsequent values.

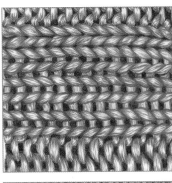

STEP THREE To indicate the fibers of the yarn, use a 2B pencil and short, tapered strokes that follow the curves of the strands. Maintain a sharp pencil point as you apply the strokes, and work around the highlights on each strand.

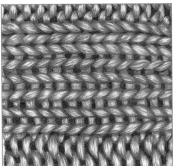

STEP FOUR With a small stump or tortillion, lightly blend throughout to give the knitted design a little bit of a smoother look.

Woven Basket in Graphite

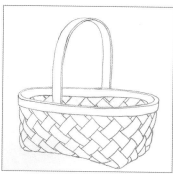

STEP ONE To begin this woven texture, draw the outline of the basket using light strokes. (The lines shown here are darker for demonstration purposes.)

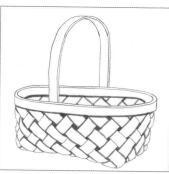

STEP TWO With a 4B pencil, fill in the areas between the weaves. Use a 2B to thicken any lines where the weaves cross over one other, suggesting slight shadows. Also, still using the 2B, draw a thin shadow below the top rim of the basket.

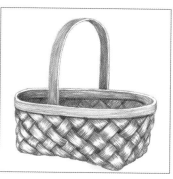

STEP THREE For the exterior of the basket, use an HB pencil to draw tapered strokes coming out from both sides of the weaves, working around a highlight on each weave. For the interior weave, use a 2B and closely placed hatch marks to push it back into shadow. On the interior rim and inside of the handle, suggest shadow by applying long strokes that follow the curvature of the form. On the outer areas of the hand and rim, use a 2H and long strokes to simulate the grain.

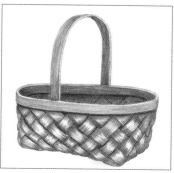

STEP FOUR Use a small stump to blend your strokes, focusing on the areas in shadow such as the handle, rim, basket interior, and areas where the weaves intersect. To finish, maintain contrast in the drawing by darkening any areas that have lightened during the blending process.

40 Woven Basket in Charcoal

STEP ONE Begin by drawing a light outline with a hard pencil, such as a 2H. Once satisfied, trace over the drawing with a 2H charcoal pencil. For this subject matter, tan-colored charcoal drawing paper works well.

STEP TWO Use a soft charcoal pencil, such as a 3B, to fill in the darkest areas of value between the weaves of the basket.

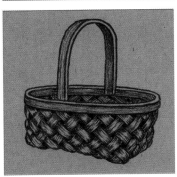

STEP THREE Use short, tapered strokes with an extra-hard 2H charcoal pencil on the weaves of the basket exterior, leaving the middle of each weave free of tone to suggest a highlight. Apply straight, closely placed hatch marks on the interior weave using a 3B charcoal pencil, pushing it back into shadow. With the 2H charcoal pencil, apply long strokes on the outside rim and handle of the basket, following the curves of the forms. Use the 3B charcoal pencil on the shadows of the handle and side rim of the basket.

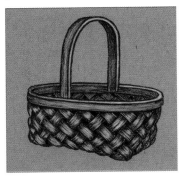

STEP FOUR For more contrast, you can bring out highlights with a few strokes of white charcoal pencil. Apply these strokes on the outside rim, on the handle, and on the exterior weave.

41 **Twine** in Graphite

STEP ONE Twine is a thin, strong cord made up of several threads twisted together. This example is a close-up view of a spool of twine. Begin by outlining the individual cords and twists using a 2B pencil. Note that the twists of the cords are basically "S" shapes.

STEP TWO Using a 4B pencil, fill in the dark areas between the cords. Round off the twists of the cord slightly for definition.

STEP THREE Using an HB pencil and starting on each side of the twist, create small, tapered strokes that follow the slight curve of the twists in the cord. Notice how the tapered strokes in this example are enough to allow some white of the paper to show through, giving the twists in the cord a highlighted effect.

STEP FOUR With the HB pencil, add some light shadowing to one side of the cord, working from top to bottom, and to the deeper, underlying cords. Then, blend your shadows throughout using a small stump or tortillon, smoothing the strokes and toning any white areas of paper that may still be showing through.

42 **Cork** in Graphite

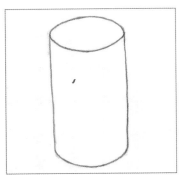

STEP ONE This example features cork from a wine bottle. Begin by drawing a basic cylinder, making sure the ellipse is symmetrical to represent the cork top viewed from an angle.

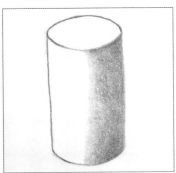

STEP TWO Use an HB pencil and overlapping circular strokes to create a shadow along the right side. This will serve as the basis for its three-dimensional appearance.

STEP THREE Some corks are fairly smooth and some have character, such as this one. To create imperfections across the surface, use sharp pencils of various hardnesses to create nicks and cracks. Some of the imperfections may be deep, creating shadows and highlights.

STEP FOUR Using the graphite already embedded in a small stump, smooth out some areas of the cork and create subtly darker areas across the surface.

GLASS, STONE, CERAMICS, WOOD & METAL

43 **Beveled Glass** in Graphite

STEP ONE This texture is part of a decorative window made of beveled glass. Note that the unique tones and shapes in the reflective glass will depend on what is behind your subject. To begin, use a ruler to draw any square angles. Use an oval template (or simply work freehand) to create the center shape. Use very light lines to develop the beveled areas of glass, but switch to a 4B to thicken the lines representing the window's lead strips.

STEP TWO With a 2B pencil, create the darkest reflections in the window. This will provide a gauge for adding subsequent values. Use overlapping, circular strokes to create an even tone. For a realistic look, leave a slightly lighter edge between the glass and lead strips.

STEP THREE Using HB and 2H pencils, create the lightest values within the reflection. Leave some of the paper white to suggest the lightest reflections.

STEP FOUR Use a small blending stump to blend as evenly as possible. You may need to reapply graphite to recover any darks that have lightened during blending. If desired, you can also create areas of lighter reflections by removing tone with a click pencil eraser.

Clear Glass in Graphite

44

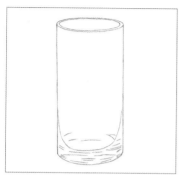

STEP ONE This example features a basic clear drinking glass in simple lighting. Begin by outlining the subject with light strokes, including the various distorted reflections that show through at the base of the glass for a realistic touch.

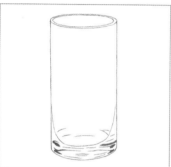

STEP TWO With a 4B pencil, lay in the darkest values found in the distorted reflections at the base of the glass.

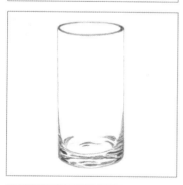

STEP THREE Using HB and 2H pencils, fill in the subtle variations of tone around the base and rim of the glass.

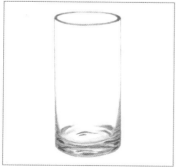

STEP FOUR Using a small, sharp-tipped blending stump, blend the base and rim so they appear smooth. In cases where the 2H pencil may be too dark, you can use the tip of the stump to place light tone on the drawing paper.

45 **Porcelain** in Graphite

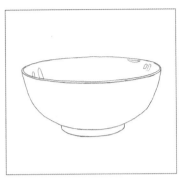

STEP ONE Porcelain is a delicate ceramic that has been baked at a high temperature. This example shows a bowl with a smooth, white finish. Start with an outline of the bowl. Include the outlines of the small reflections with very light, erasable lines, which will later serve as highlights. (The lines shown here are much darker for demonstration purposes.)

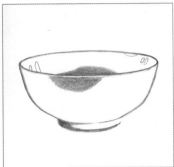

STEP TWO With an HB pencil and overlapping circular strokes, create a thin line of tone around the rim of the bowl for depth. Also, still using the HB pencil and overlapping circular strokes, create areas of darker shadow on the inside of the bowl, on the outside of the bowl, and on the base of the bowl.

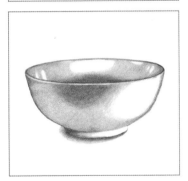

STEP THREE With a 2H pencil and overlapping strokes, work around the small and large highlights on the bowl as you add a middle value. Then create a cast shadow and add some lighter shadows around the base.

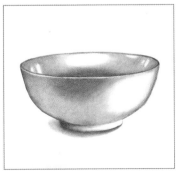

STEP FOUR Finish by using a stump to smooth and blend all areas of the bowl. A larger stump with a well-used blunt end works well to create a smooth finish for this subject. Alternatively, you can create ultra-soft blends with the tip of a folded tissue.

Polished Sterling Silver in Graphite

STEP ONE A reflective subject like this involves complex shapes with plenty of changes in value. When creating the initial sketch, use very light lines. (The lines shown here are darker for demonstration purposes.)

STEP TWO Using a 4B pencil, apply the darkest values first. Set against the white of the paper, these darks will help you better determine the remaining values needed to complete the scene. Use overlapping circular strokes, which you will later blend to a smooth finish. Switch to a 2B and apply a slightly lighter value. Again, use overlapping circular strokes, beginning in the 4B areas and working outward to create a gradation.

STEP THREE Now use an HB pencil and overlapping circular strokes to add another lighter value, again working outward from the areas of 2B.

STEP FOUR With a hard 2H pencil, complete the reflective areas using overlapping circular strokes. Then add the light cast shadow of the plate. When blending small areas, a tortillon may be a better choice than a stump. For this subject, use a tortillon everywhere except the center of the plate. For the center, blend with a large, well-worn stump that is already coated in graphite; follow up by blending with tissue for a smooth finish.

47 **Hammered Metal** in Graphite

STEP ONE Hammered metal is a dented pattern used to texturize copper, gold, and other metals used in jewelry. To begin, use a 2B pencil to draw small arches indicating the shadowed areas of the hammered metal.

STEP TWO Still using the 2B, apply overlapping circular strokes for the areas of shadow. Because hammered metal can have a rough appearance, you can be loose in this step.

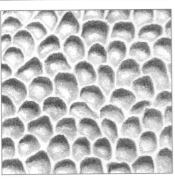

STEP THREE Switching to a much lighter 2H pencil, use overlapping circular strokes to create the rest of each dent shape. Leave a small border around them, and avoid applying tone over the center of each dent to indicate highlights.

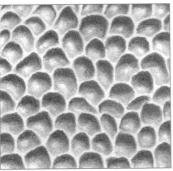

STEP FOUR With a small stump, lightly blend your strokes. Leave some of the pencil strokes showing through to retain a rough, hammered look. Remember to keep the borders and centers of the dents free of tone for a highlighted look.

48 Hammered Metal in Charcoal

STEP ONE For this textured metal surface, use a 3B charcoal pencil to draw small arches indicating the shadow of each dent.

STEP TWO Still using the 3B, apply small hatch marks to create the shadows. Note that all the shadows fall in the same direction, showing that the light is coming from the top.

STEP THREE With a much lighter 2H charcoal pencil and light hatch marks, continue developing the dents or divots. Remember to leave a clean, tone-free border around them.

STEP FOUR Using a small stump, very lightly blend while allowing some of the strokes to show through for a textured look.

49 **Clay Pottery** in Graphite

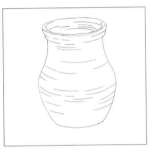

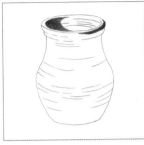

STEP ONE This example features clay pottery created on a potter's wheel. To begin, outline the shapes of the pottery. The exterior should not be perfectly smooth, which you can reflect in your outline as you follow the pottery's curvature.

STEP TWO Apply the darkest values first, which will provide a gauge for applying subsequent values while maintaining effective contrast. For this step, use a 4B pencil with overlapping circular strokes.

STEP THREE Switch to a 2B pencil and use overlapping circular strokes to add slightly lighter values, blending out from the areas of 4B to avoid a visible transition. Then darken the lines over the pottery. Working in overlapping circular strokes will help you retain the rough texture of pottery.

STEP FOUR Now switch to an HB to build a lighter value, working outward from the areas of 2B for a smooth gradation of tone. Use the HB to thicken the lines on the pottery, which will show through any subsequent values.

STEP FIVE Using a 2H and overlapping circular strokes, fill in the remaining light areas of the pottery. Again, creating a gradation as you move away from the darker areas.

STEP SIX Lightly blend using a large stump, being careful to allow the lines and some texture of the overlapping strokes to show through. At this point, you can use a kneaded eraser to pull out more highlights for depth, contrast, and a three-dimensional appearance. To bring out highlights around the lip of the pot, consider using a click pencil eraser.

Rusted Steel in Graphite

STEP ONE Drawing realistic rusted steel is surprisingly simple, requiring a combination of stippling and scribbling strokes. To begin, draw the outline of your subject with light lines. (The lines shown here are darker for demonstration purposes.) This example of rusted steel could be part of an old, abandoned ship door held together with rivets.

STEP TWO To establish contrast, use a 4B pencil to create the darkest shadows. Use a thin crescent moon shape to suggest the domed form of each rivet.

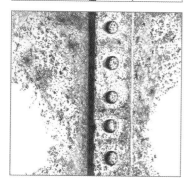

STEP THREE To suggest pitting and rust, apply stippling (small dots) and overlap it with small, scribbling strokes. Vary the concentration of your stippling to make some areas lighter and some darker, and vary the lightness and darkness of your patches of scribbling as well for interest and realism.

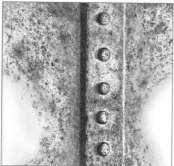

STEP FOUR To finish, blend random areas while leaving some as they are for variation and interest. You may need to revisit some areas to create more texture or contrast after blending, as the blending process can lighten the overall tone.

51 **Smooth Concrete** in Graphite

STEP ONE Smooth concrete, sometimes used for workshop floors, can have a very polished, reflective finish. This example shows a polished concrete floor with the reflection of overhead lights. To begin, use very light, easily erasable lines to show where the reflected light will be on the floor. (The lines shown here are darker for demonstration purposes.)

STEP TWO Using the side of the tip of a 2B pencil, apply wide lines with long strokes. Cover most of the floor, working around the reflected lights.

STEP THREE With a large, blunt, well-used stump, blend your strokes, again working around the reflections. Some areas will appear uneven in tone, reflecting the variance of real concrete. If the concrete is too even in tone, you can easily add more graphite using the side of the tip of the 2B pencil, followed by blending.

STEP FOUR Again using the stump, lightly apply graphite around the areas of reflection, leaving the white of the paper as the brightest spot in the center of each. To make the concrete appear more realistic and uneven in tone, use a kneaded eraser to pull up some graphite. If needed, use a click pencil eraser to recover the brightest areas in the center of each reflection.

Stucco in Graphite

STEP ONE Stucco is a type of cement that is applied to the exteriors of some houses and buildings. This example features just one style (or finish) of stucco. Begin by drawing different sizes of random forms. Use very light, easily erasable lines; the lines shown in this example are darker for demonstration purposes.

STEP TWO Choose the side from which the light will shine. Then, with an HB pencil, draw a very thin shadow line on each shape, opposite the side of the incoming light.

STEP THREE Continuing with the HB pencil, stipple in the areas between the main shapes. Make the stippling somewhat random.

STEP FOUR Use a sharp-tipped tortillon or stump to lightly blend the thin areas of shadow. To finish, use an older stump or tortillon to "draw" across the stucco, leaving wide, light lines to indicate trowel marks for realism and interest.

53 | **Brick** in Charcoal

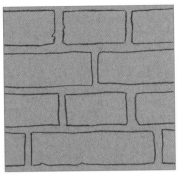

STEP ONE Working on charcoal paper, draw the outlines of your bricks using light pencil or a 2H charcoal pencil.

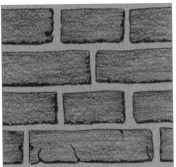

STEP TWO Using the side of a piece of hard (2H) charcoal or the side of the tip of a 2H charcoal pencil, cover the entire face of each brick. The roughness or "tooth" of the charcoal paper will help give the bricks a textured look. Then, using a darker or softer charcoal such as 3B, apply a thin, rough shadow on each side of the brick. Add some random cracks in the bricks if desired.

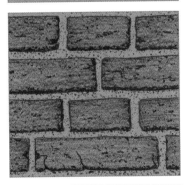

STEP THREE With the 3B charcoal pencil, add some stippling to both the mortar and the faces of the bricks.

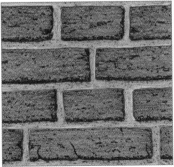

STEP FOUR Depending upon the tone of your paper, you may want to add light strokes of white charcoal pencil over the mortar for more contrast.

Old Brick in Graphite

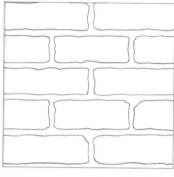

STEP ONE Start with a lightly drawn outline of a brick wall. (The lines shown here are darker for demonstration purposes.) Because these are old bricks, they have rounded corners that show wear.

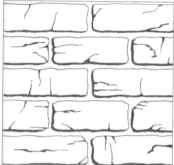

STEP TWO Old bricks feature cracks and imperfections. Use a 4B pencil to indicate the shadows of cracks. Still using the 4B, apply the dark shadows of the bricks. Note: The lines that are not in the shadow should be drawn much lighter than shown here, which will increase contrast and depth in the finished drawing.

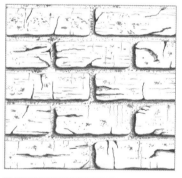

STEP THREE With an HB pencil, create more light cracks in a random fashion. Then add pitting and stippling on the faces of the bricks and within the mortar. Use the HB pencil to draw a light, thin edge of shadow coming out of the deeper cracks and along the dark shadows on the edges of the bricks, suggesting depth.

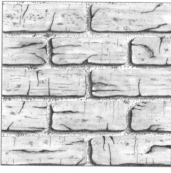

STEP FOUR With a small stump, very lightly blend the shadows around the edges of the bricks. With an older stump already coated with graphite, lightly blend the face of each brick to smooth the texture and add tone. If you desire a darker value, simply add graphite powder (saved from pencil shavings) to the end of the stump.

55 **Cobblestone** in Graphite

STEP ONE Some cobblestone pathways can appear very old and weathered, full of cracks and rounded corners. To begin, outline the pathway in perspective as it relates to the viewer. Also, think about where the shadows will fall.

STEP TWO Fill in the darkest areas of shadow with a 4B pencil. In the areas between the bricks, suggest mortar and dirt by lightly scribbling with an HB pencil.

STEP THREE With a 2B pencil, create some small cracks, lines, and stippling on the surface of the bricks. Use an HB pencil and long, light, tapered strokes across the surface of the bricks to give them contrast. Leave the centers of some bricks free of tone to suggest depth.

STEP FOUR To finish, very lightly blend the bricks. Allow some of the pencil strokes to show through to give the bricks a little surface texture.

56 **Marble** in Graphite

STEP ONE Marble generally features interesting natural designs or cracks. You can use a photo reference or make up your own designs, as I did here. Start with a dark (soft) pencil, such as a 2B or 4B, and indicate the cracks and grains.

STEP TWO The lines within marble can be irregular in thickness. Use your 2B or 4B to thicken some areas of the initial outline.

STEP THREE Using a lighter pencil, such as an H or HB, create more freehand designs again, keeping some of the line thick and some thin.

STEP FOUR Use a 2H pencil to add fine lines for more interest.

STEP FIVE On some marble, the natural dark coloring of the lines and cracks penetrate deeply, which makes some lines appear to be surrounded by shadow. To suggest this, use a small stump or tortillon to blend lightly over the lines and spread the graphite.

57 Driftwood in Charcoal

STEP ONE To represent the cooler tones of driftwood, work on gray paper. Using a B charcoal pencil, create cracks and lines of wood grain. Work in a wavy pattern to suggest the warped, uneven surface. Rotate your pencil as you work to maintain a sharp tip.

STEP TWO With an HB charcoal pencil, thicken some of your lines and fill in the larger cracks, leaving the ends tapered to suggest the narrow splitting of wood.

STEP THREE Switch to a 2H pencil to create light strokes that follow the grain. Suggest areas of discoloration by applying loose, uneven tone.

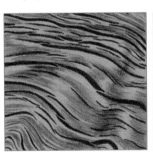
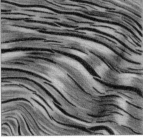

STEP FOUR Use a stump to lightly blend the discolored areas, which will give it a smoother appearance.

STEP FIVE Create highlights and areas of lighter tone using a white charcoal pencil. This will create more contrast and strengthen the sense of light falling on the wood.

58 **Smooth Wood** in Graphite

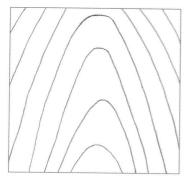

STEP ONE When cut and sanded, wood can produce a variety of beautiful patterns and textures. To re-create this basic wood texture, begin by outlining the rings with very light lines. (The lines shown here are darker for demonstration purposes.)

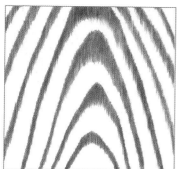

STEP TWO Using a 2B pencil, apply closely placed short, vertical strokes that follow the arch of the rings. Notice how the thickness of each arch varies from the sides to the top.

STEP THREE Using an HB pencil, apply more vertical strokes extending downward from the initial lines created in Step Two. Vary your stroke length, applying both long and short strokes to create the appearance of a subtle gradation of tone from the top of the each arch.

STEP FOUR Finally, blend with a stump to create a smooth finish. For an even smoother appearance, as shown here, blend with a tissue folded to a narrow triangle. Some of the pencil strokes should still show through after blending to retain the realistic look of wood grain.

59 **Aged Wood** in Graphite

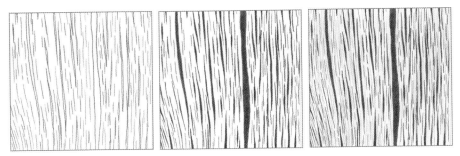

STEP ONE Aged wood is a beautiful texture with cracks and character that can lend interest to any composition. Begin by drawing the large and small cracks on the surface. You can use a soft 4B pencil for this step, as these lines will later be in shadow.

STEP TWO Continuing with the 4B pencil, widen some of your lines and fill in the cracks. Leave tapered ends on each crack to indicate the splitting of the wood.

STEP THREE With a 2H pencil, apply long strokes to indicate light wood grain. Note: When creating long strokes, it's best to keep your wrist steady and move your arm at the elbow.

 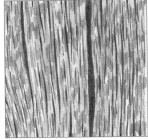

STEP FOUR Using an HB pencil, apply tone to suggest patches of discoloration. When drawing wide strokes such as these, hold the pencil at a steep angle to the paper, working with the side of the graphite rather than the sharp tip.

STEP FIVE To finish, lightly blend the patches and some areas of the wood grain.

78

Aged Wood in Charcoal

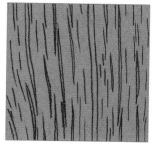
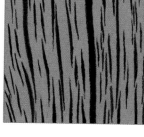
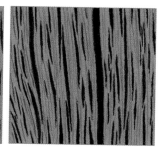

STEP ONE Aged wood is a beautiful texture with cracks and character that can lend interest to any composition. Begin by drawing the large and small cracks on the surface using an HB charcoal pencil The lines in this step can be dark, as they will later be in shadow.

STEP TWO Continuing with the HB, widen your lines and fill in the cracks. Leave tapered ends to suggest the realistic splitting of old wood.

STEP THREE Switching to a harder 2H charcoal pencil, apply long, thin strokes to create the grain of the wood. Note: Charcoal pencil can dull quickly and form a sharp, chiseled end on the very tip after you stroke. Instead of continually sharpening the pencil, simply rotate the pencil between each stroke.

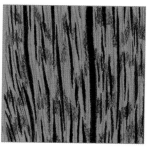
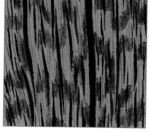
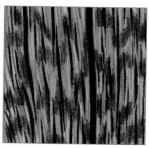

STEP FOUR Again utilizing the HB charcoal pencil, use a light touch to create scattered patches of tone on the wood.

STEP FIVE Very lightly blend the dark patches, leaving the cracks and light wood grain untouched.

STEP SIX For more interest and contrast, use a white charcoal pencil to highlight select areas of the wood. Avoid stroking over the cracks or dark patches as much as possible.

61 **Wood Knot** in Graphite

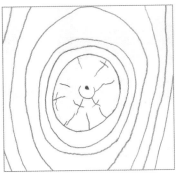

STEP ONE When drawing wood, including a wood knot or two can add interest to the finished work. To begin, outline the shape of the knot along with a few small cracks. Also, outline the wood grain around the knot. Use light lines for this step; the lines shown here are darker for demonstration purposes.

STEP TWO The knot in the wood is often a bit darker than the wood surrounding it. In this case, use an HB pencil with small, overlapping circular strokes. Switch to a 2B when working in the very center. Darken the cracks with a 4B pencil, keeping them tapered at the ends.

STEP THREE With an HB, draw closely placed vertical strokes to represent wood grain around the knot. With a very sharp 2B pencil, create tiny growth rings in the knot itself.

STEP FOUR To finish, use a small stump or tortillon to blend around the outside of the knot, softening its edge. Also, blend the grain of the wood around the knot, allowing most of the lines to show through for texture.

Wooden Barrel in Graphite

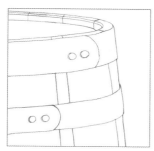
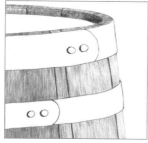
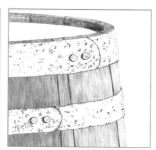

STEP ONE To begin, use light lines to outline the wooden barrel. (The lines shown here are darker for demonstration purposes.) The top of the barrel is an ellipse, which must be drawn accurately and symmetrically to suggest realistic perspective. Then use a 4B to create the darkest shadows in the drawing, including the shadows on top of the barrel, the lines between the wooden slats, and the rivet shadows.

STEP TWO Next, use a 2B pencil and short, overlapping hatch strokes to create the grain in the oak slats. Note how the grain direction appears along the rim. Because the light is coming from the right, use fewer hatch strokes on the right side to allow more of the white paper to show through. You can also switch to an HB to create lighter strokes on the lit side of the barrel.

STEP THREE For more interest, the metal bands on the barrel can show a bit of rust. (See "Rusted Steel in Graphite" on page 50.) To begin, stipple in an irregular fashion over the bands with a 4B pencil.

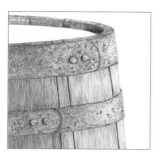
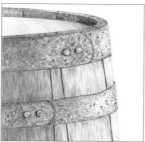
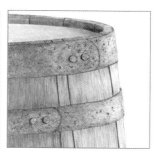

STEP FOUR Apply scribbling strokes over the bands to complete the metal's rusty appearance. Remembering the direction of the light source, use lighter coverage on the right side of the bands. Also, use a 2B for the darker part of the bands and an HB for the lighter side.

STEP FIVE On the top lid of the barrel, apply light, long parallel strokes with a 2H to suggest a hint of wood grain.

STEP SIX To finish, use a stump to very lightly blend the wood grain of the barrel and lid. Use heavier blending for the metal, but make sure to allow the stippling and scribbling to show through.

63 **Wrought Iron** in Graphite

STEP ONE Wrought iron, which is often used in fences and gates, generally comes in black or brown. This example features a simple design in black wrought iron. Begin with a light outline; the lines shown here are darker for demonstration purposes.

STEP TWO Using a 4B, fill in the darkest values first. Set against the white of the paper, the darks will provide a gauge for applying subsequent values. Add some stippling to suggest small defects and occasional rough areas for interest. For especially weathered and rusty wrought iron, add more imperfections.

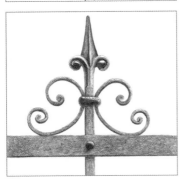

STEP THREE Use loose, overlapping strokes (or even some scribbling) to fill in the surface of the wrought iron. Switch between 2B and HB pencils for varying values. To show the direction of light and suggest depth, leave some areas free of tone to allow the white of the paper to serve as the highlight. These areas include the two raised round areas at the base of the point, the single rivet, and the small band around the two curled designs.

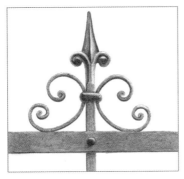

STEP FOUR To finish, use a medium to small stump or tortillon to blend and smooth your strokes. Use less blending to suggest rougher wrought iron. To create more areas of highlight throughout the design, lift graphite with a kneaded eraser, always keeping in mind the direction of light.

Wrought Iron in Charcoal

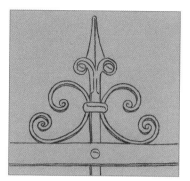

STEP ONE A gray-toned charcoal paper is a good choice for this dark subject matter. Begin by drawing light outlines with a graphite pencil or hard charcoal pencil. (The lines shown here are darker for demonstration purposes.)

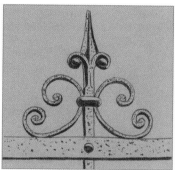

STEP TWO Using a dark, soft charcoal pencil such as a 3B, apply the darkest values of the scene, including all areas of shadow. To add more interest and realism, stipple the face of the wrought iron with the 3B charcoal pencil. This will create a rusty, aged look. (If desired, you can skip this step for a cleaner, newer feel.)

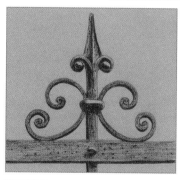

STEP THREE Again using the 3B charcoal pencil, very lightly stroke over the face of the wrought iron, allowing the texture of the gray paper to show through.

STEP FOUR To finish, use a white charcoal pencil to bring out highlighted areas. If you desire a smoother look, lightly blend the drawing with a stump.

65 **Granite** in Graphite

STEP ONE In this example of granite, no initial outline is needed. Simply begin by using a 4B pencil to draw random, splotchy shapes and stippling. You can use a granite countertop for reference, if needed.

STEP TWO With a 2B pencil, create striations—a series of parallel lines that depict a crystalline structure of granite.

STEP THREE Switch to a lighter HB pencil and continue building striations, imitating the variations seen in real graphite.

STEP FOUR Finish by very lightly blending the striations, allowing the pencil strokes to show through for texture.

Granite in Charcoal

STEP ONE When drawing granite in charcoal, you can choose from a variety of toned papers to realistically imitate the color of your reference. To begin, create dark, splotchy shapes using a 3B charcoal pencil. Follow up by randomly stippling throughout.

STEP TWO With slightly lighter (harder) charcoal pencils, such as 2B and HB, create some striations to depict the crystalline structure of granite.

STEP THREE Very lightly blend the striations, allowing most of the individual lines to show through.

STEP FOUR With a white charcoal pencil, add some white spotted areas to indicate white crystal in the granite.

67 Cast Iron in Charcoal

STEP ONE For this cast iron pan drawing, choose a gray charcoal paper. Use a hard charcoal pencil or an HB graphite pencil to create light outlines.

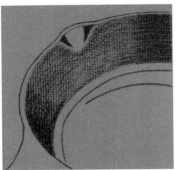

STEP TWO With a 3B charcoal pencil, apply the darkest values of the pan first. This will provide a gauge for developing subsequent values, and it will help you maintain much-needed contrast throughout the drawing process. Work in strokes that follow the curvature of the pan. Switching to an HB charcoal pencil, apply slightly lighter values. The charcoal paper used in this example is very rough, which helps depict the textured surface of actual cast iron.

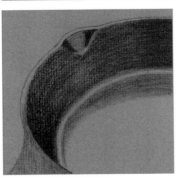

STEP THREE With a 2H charcoal pencil, create the small, lighter area at the bottom of the pan. With a stump, very lightly blend all areas of the pan, allowing some of the texture to show through. Leave some of the paper free of tone to indicate a lighter value of the pan.

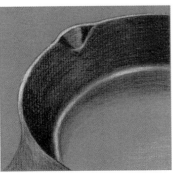

STEP FOUR With a white charcoal pencil, create highlights along the rim and in the bottom of the pan.

Rock Wall in Graphite

STEP ONE To begin, outline the basic shapes of the rock wall. In drawings like this, you can use a reference photo or rely simply on your imagination. Note: It's a good idea to carry a camera often and collect photos of various textures, which you can use as future references.

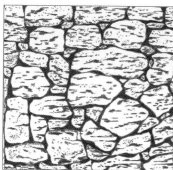

STEP TWO Using a 4B pencil, fill in the darkest areas of shadow between the individual rocks. Switch to a 2B pencil and create random crack shadows and crevices on the faces of the rocks. Further texture them with some stippling.

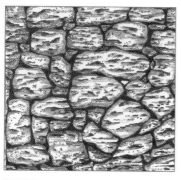

STEP THREE With an HB pencil, add lighter shadows to the cracks and crevices, and create shadows around the edges of each rock to suggest depth.

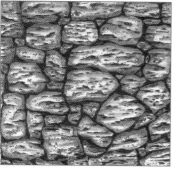

STEP FOUR With a small stump, lightly blend the shadows added with the 2B and HB pencils.

FOOD & BEVERAGES

Glass of Wine in Graphite

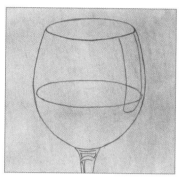

STEP ONE Some drawings call for a subtle background that allows the highlights to "pop." For this glass of wine, tone the background by using a chamois to lightly apply graphite powder (collected from pencil shavings). Then use a 2B pencil to lightly draw an outline of the wine glass and wine. (The lines shown here are darker for demonstration purposes.)

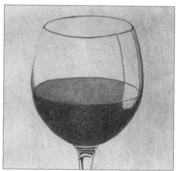

STEP TWO Apply the darkest values to the wine and areas of shadow within the glass using tight, overlapping circular pencil strokes. You will blend these strokes at a later stage. Using an HB pencil, again with tight, overlapping circular strokes, apply another layer of value over the wine, stem, and base of the glass. Work around the highlighted areas for now.

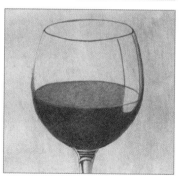

STEP THREE With a 2H pencil, create the light, reflective areas on the stem and base of the glass.

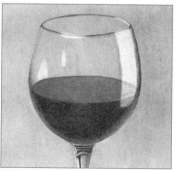

STEP FOUR With a click pencil eraser, create the highlights at the base, stem, outside, and rim of the glass. Lightly blend the wine in the glass, along the stem, and within the base of the glass. Using a graphite-coated stump, lightly apply some tone to the small areas of wine for variation within the large reflection on the glass.

70 Citrus Fruit Rind in Graphite

STEP ONE Begin with a simple outline of the rind using light lines (the lines shown here are darker for demonstration purposes). A 2H works well for this step.

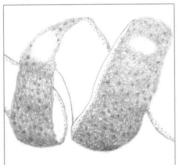

STEP TWO Use an HB pencil to apply loose, overlapping strokes, which will give the rind a realistic look after blending. Allow the white of the paper to show through your strokes, and avoid applying tone over the two highlights on the rind's surface. Stipple the rind to represent scattered dimples. Next, thicken the lines representing the cut skin and stipple along the edge.

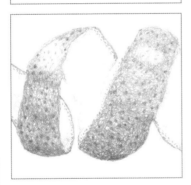

STEP THREE With a 2H pencil, fill in the highlighted areas with very loose, overlapping strokes and stippling to suggest a rough texture.

STEP FOUR Use a stump to lightly blend all areas of the rind, allowing some pencil strokes to show through for texture. Lightly blend along the cut edges as well.

71 Cut Citrus Fruit in Graphite

STEP ONE Because pencil does not involve color, this can serve as an example of any citrus fruit, such as orange, lemon, or grapefruit. However, be sure to note any differences between fruits; for example, the rind of a lime is often thin. To begin, draw the outline of the cut citrus fruit using light lines (the lines shown here are darker for demonstration purposes).

STEP TWO Using an HB pencil, thicken the outer edge and add some stippling along the cut rind. Darken the very center to show that it's in shadow.

STEP THREE Still using the HB, create pointed, tapered shapes to represent the pulp. Fill in the space around the shapes (called "negative drawing"; see page 11).

STEP FOUR To finish, blend lightly around the edge of the cut rind using a small stump. Around the tapered shapes in the fruit, use a small, sharp-pointed tortillon to blend within the smallest areas.

72 Apple in Graphite

STEP ONE Begin by creating a basic outline with a 2H pencil. You can begin with a simple circle and then refine the sketch to include the bumps and bulges of an apple.

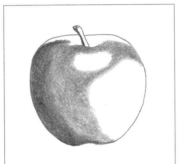

STEP TWO Decide which direction the light is coming from; in this example, it is coming from the right. Then create the shadowed area on the left side, which will serve as the darkest value, using a 2B pencil and overlapping circular strokes. You will later blend these strokes for a smooth finish. Continue using an HB pencil and overlapping circular strokes to apply a slightly lighter value to the apple, leaving an oval highlight area near the top free of tone.

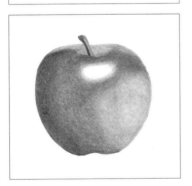

STEP THREE With a lighter 2H pencil and overlapping circular strokes, coat the rest of the apple, still leaving the oval highlighted area at top free of tone. Using a stump, blend all areas of the apple to a fairly smooth finish.

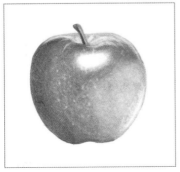

STEP FOUR Using a small-tipped click pencil eraser, create lighter spots and lines around the stem and top of the apple. Also, create some light stippled spots on the skin. Finally, suggest reflected light by removing a thin band of tone along the bottom right edge of the apple.

73 **Pear** in Graphite

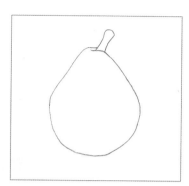

STEP ONE Begin by drawing a light outline of the pear with a 2H pencil. You can begin with a simple circle and then sketch the top of the pear. (Note that the lines shown here are darker for demonstration purposes.)

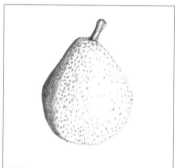

STEP TWO In this drawing, the light will be coming from the right. Begin with the darkest value—a shadow on the left side of the pear and stem. Use loose, overlapping circular strokes that allow a bit of the white paper to show through. This will give the pear skin a realistic look when finished. Then, using an HB pencil, stipple over the skin of the pear for texture.

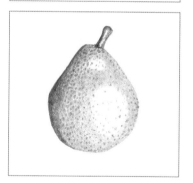

STEP THREE Switch to a 2H pencil and apply loose, overlapping circular strokes over the pear skin, leaving two areas of highlights: one on the upper portion, and one on the bottom portion.

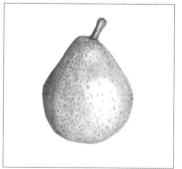

STEP FOUR Blend the pear, allowing some of the pencil strokes to show through. Leave the highlighted areas free of tone, including the thin highlight on the stem.

93

74 **Grapes** in Graphite

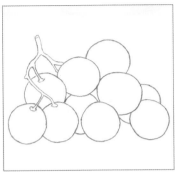

STEP ONE Using simple circles, create a basic outline of the grapes and stems. Use light strokes; the lines shown here are darker for demonstration purposes.

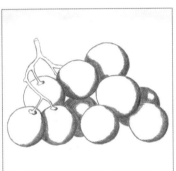

STEP TWO In this example, create the shadows with a 2B pencil. The light is coming from the upper left, so the darkest values will be the shadows at right. Apply tone with small, overlapping circular strokes, which you will later blend into a smooth finish.

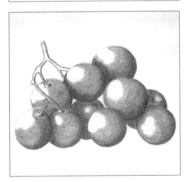

STEP THREE Apply a slightly lighter value of the grapes with an HB pencil, again using small, overlapping circular strokes. Still using the HB pencil, create the shadowed areas on the grape stems.

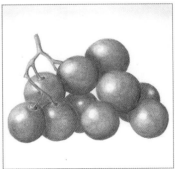

STEP FOUR Switch to a 2H pencil and apply small, overlapping strokes, leaving highlighted areas of the grapes free of tone. Then use the 2H and long hatch marks to develop the grape stems. Finish by blending the grapes to a smooth finish with a stump or tortillon, again working around the highlighted areas. To complete the drawing, lightly blend the grape stems, allowing some of the hatch marks to show through for texture.

75 **Cherry** in Graphite

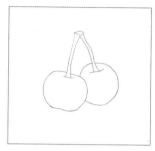
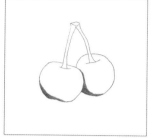
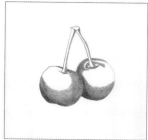

STEP ONE This example shows two cherries connected at the stems. Begin by using a 2H pencil to outline the cherry shapes and stems with very light lines (lighter than shown here).

STEP TWO The darkest value of the drawing will be the shadows on the lower part of the cherries. Use a 2B pencil to apply tone in these areas. Work in small, overlapping circular strokes, which you will later blend to a smooth finish.

STEP THREE Switch to an HB pencil and apply a slightly lighter value to the cherries, again using small, overlapping circular strokes. Then add tone to the stems, applying it along the sides opposite the light source.

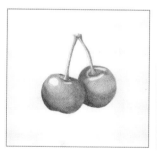
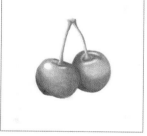
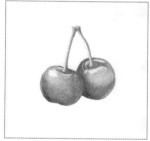

STEP FOUR For the lightest value of the cherries and stems, use a 2H pencil to develop tone. Allow the highlights to remain the white of the paper.

STEP FIVE Using a stump or tortillon, blend the cherries and stems to a smooth finish.

STEP SIX Using a small click pencil eraser, add tiny highlights for more interest and to further suggest the reflective nature of the cherries. Also, use the pencil eraser to create tiny light speckles on the skin, as seen on some varieties of cherry.

76 **Coconut** in Graphite

STEP ONE Draw the basic outline of the coconut, which has been broken in half to reveal the meat inside. Use a 2H pencil for a light outline; the lines shown here are darker for demonstration purposes.

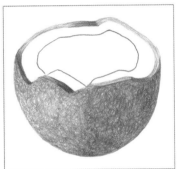

STEP TWO Coconut has a very fibrous exterior. To represent this texture, work in scribbling strokes using a 2B (for the darker right side) and an HB (for the lighter left side). Apply long strokes of the 2B and HB pencils along the cracked edge of the coconut, following the curve of the rim.

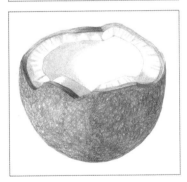

STEP THREE With a 2H pencil, create a bit of texture and light shadows on the interior and rim of the coconut meat.

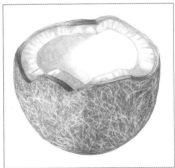

STEP FOUR Lightly blend the interior, exterior, and cracked rim of the coconut. Then use a click pencil eraser to suggest some thin, random fibers on the surface.

Strawberry in Graphite

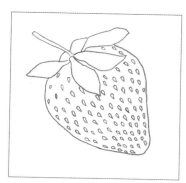

STEP ONE Begin by drawing the simple outline of a strawberry, stem, and sepal with light lines (the lines shown here are darker for demonstration purposes). Then use a 2B pencil with a sharp tip to create teardrop-shaped seeds. Note how the tip of each seed points toward the tip of the strawberry.

STEP TWO Next, using a 2B pencil, create areas of shadow on the leaves, stem, and sides of each seed on the part of the strawberry in shadow. (In this case, the light is coming from the right, putting the left side in shadow.)

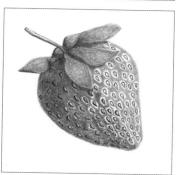

STEP THREE Using a 2B and small, tight, circular strokes, add tone to the darker side of the strawberry (left), leaving a very small amount of white paper showing around the seeds closest to the center. This will give the drawing more depth after blending. Switch to an HB and fill in the rest of the strawberry, leaving more highlighted areas (white of the paper) around the seeds. Then use the HB pencil to coat the leaves and stem with more circular strokes.

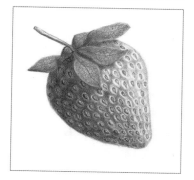

STEP FOUR To finish, use a tortillon or small stump to blend all areas of the strawberry, allowing the white of the paper to serve as the highlights. Then use a sharp HB pencil to create veins on the sepals for a realistic touch.

78 **Pineapple** in Graphite

STEP ONE Using light lines, draw the outline of the pineapple, including the crown and the individual hexagonal shapes on the exterior. (The lines shown here are darker for demonstration purposes.)

STEP TWO Use a 4B to establish the darkest values of the drawing. Work in jagged strokes around the hexagonal shapes, and use hatch strokes on the leaves of the crown.

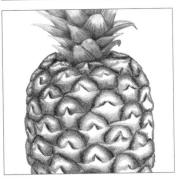

STEP THREE With a 2B pencil, use overlapping circular strokes as you work outward from the jagged strokes to create a slightly lighter value. Also use the 2B and hatch strokes to build tone on the leaves of the crown. Switch to a 2H and stroke in the rest of the leaves as you move toward the tips. Then use the 2H and overlapping circular strokes to establish the lighter areas of the hexagonal shapes, leaving some areas as the white of the paper for highlights.

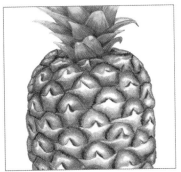

STEP FOUR To finish, use a stump to lightly blend all areas of the pineapple.

Corn in Graphite

STEP ONE Begin by drawing a basic outline of the ear of corn, which includes the husk for more interest. Use a 2H pencil for this step; the lines shown here are darker for demonstration purposes.

STEP TWO To make sure the finished drawing features adequate contrast, use a 4B to develop the shadows. Apply dark tone between the kernels and along the husk in long strokes.

STEP THREE Using an HB pencil, create more lines along the husk. Then apply tight, overlapping circular strokes around the edges of the kernels, leaving the center of each free of tone to represent highlights.

STEP FOUR To finish, lightly blend the lines on the husk with a stump. Then smoothly blend the strokes in each kernel, leaving the white of the paper to serve as a highlight in the center.

80 **Broccoli** in Graphite

STEP ONE This example includes a cut piece of broccoli with a bit of stalk. It's a good idea to include some small leaves for interest. Start with a basic light outline; the lines shown here are darker for demonstration purposes.

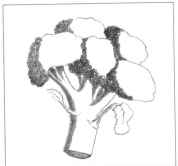

STEP TWO Using a 2B pencil, establish the darkest values in the heads and stalk, which are tilted toward the light source. Create the buds on the heads by drawing small, overlapping circles close together and allowing some of the white paper to show through, especially within lighter areas. On the stalk and stems, use tight, overlapping circular strokes that will blend smoothly in the final stages of the drawing.

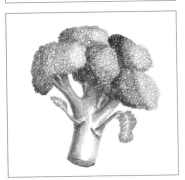

STEP THREE In the same areas, use an HB pencil to develop slightly lighter values, followed by a 2H for the lightest areas closest to the light source. Use an HB pencil to fill in the leaves, working around the white veins.

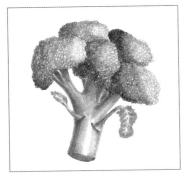

STEP FOUR Finish by lightly blending the stalk and stems using a small stump or tortillon. On the head, blend very lightly if at all. Use a small, fine-tipped tortillon to blend around the veins of the leaves, keeping them white. Tip: It's good to maintain a supply of new stumps and tortillons so you can use the sharp, unused tips for fine details.

81 **Tomato** in Graphite

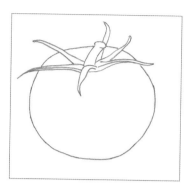

STEP ONE Begin with an outline of the tomato, stem, and sepals. Use light lines for this step; the lines shown here are darker for demonstration purposes.

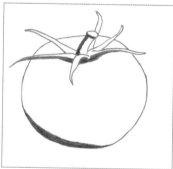

STEP TWO With a 4B pencil, create the darkest values of the drawing. These areas include the shadowed bottom of the tomato, side of the stem, and undersides of the sepal.

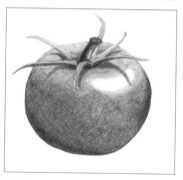

STEP THREE With 2B and HB pencils and overlapping circular strokes, create the next darkest values of the tomato. Work around the highlight, which is closest to the light source. Use the 2B to develop shadows cast by the sepal. Use the HB pencil on the surface of the sepal and on the stem, leaving a small, thin highlight.

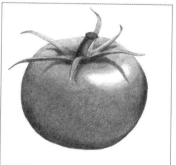

STEP FOUR Use a stump to evenly blend the body of the tomato, and switch to a small tortillon for the stem and sepal.

82 Peanut Shell in Charcoal

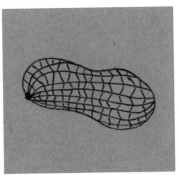

STEP ONE In this example, a tan-colored charcoal paper is a good match for drawing a peanut shell. Begin by drawing a basic outline using a 2H graphite pencil or using a 2H hard charcoal pencil with a light touch. Notice the mixture of recessed square and triangular shapes that make up the surface of the shell.

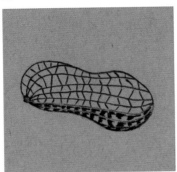

STEP TWO The darkest values will be the shadows along the bottom of the shell. Use a B charcoal pencil to develop the shadows within the small recesses.

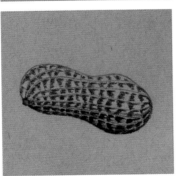

STEP THREE Next use a 2H charcoal pencil to apply the next darkest value near the bottom of the peanut shell. Use this same pencil to apply light shadows to the remaining recessed areas. Notice how the veins along the peanut shell are left as the color of the paper for now.

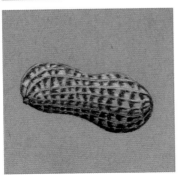

STEP FOUR Finish by simply using a white charcoal pencil to create highlights along the veins and within some of the recessed areas near the light source.

83 **Walnut Shell** in Charcoal

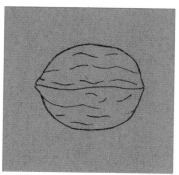

STEP ONE A tan-colored charcoal paper is a good match for drawing a walnut shell in charcoal. Begin by drawing the basic shape of the walnut, indicating the line through the middle and the creases on the shell's surface.

STEP TWO Establish the darkest value of the drawing with a 3B charcoal pencil, filling in the shadows and creases of the walnut shell.

STEP THREE With a harder 2H charcoal pencil, create light shadows moving out from the darker ones to create a gradation, and suggest a few shallow creases on the shell.

STEP FOUR To finish, lightly blend the darker and lighter shadowed creases. Then use a sharp 2H charcoal pencil to create thin veins on the shell's surface. Use a white charcoal pencil to add highlights along the top of the shell.

NATURE

Smooth Bark in Graphite

STEP ONE Smooth bark can be found on a variety of trees, making this a useful texture to master. This example of white birch features very smooth bark and some imperfections for interest; you may choose to include fewer imperfections. Begin by drawing two vertical lines for the trunk and a series of horizontal lines to indicate imperfections in the bark. Use light lines for this step; the lines shown here are darker for demonstration purposes.

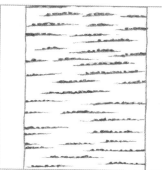

STEP TWO Using a 2B pencil, thicken and taper the horizontal lines and stipple to represent holes in the lines of the bark.

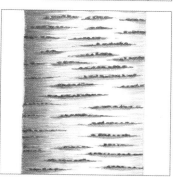

STEP THREE With an HB pencil and very slightly curved horizontal strokes, create the shadowed side of the tree (at left). Then, using a lighter 2H pencil, continue creating the curved, horizontal strokes to create a smooth transition from the HB strokes. Apply just a few of these strokes along the right edge of the tree using the 2H pencil, which suggests the curvature of the trunk.

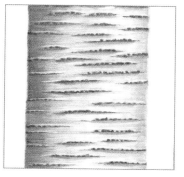

STEP FOUR To finish, use a stump to blend all areas of the bark, including the imperfections. Then use a click eraser with the tip cut at an angle to pull out some thin highlights above the imperfections, making them appear slightly raised.

85 Rough Bark in Graphite

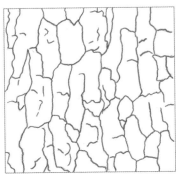

STEP ONE To begin, use a 2B pencil to outline the rough bark. In this example, you can use dark outlines because they will serve as shadows in the final drawing.

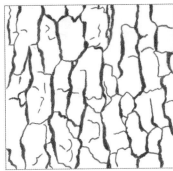

STEP TWO With a 4B pencil, establish the darkest values of the drawing within the deep, shadowed cracks of the rough bark.

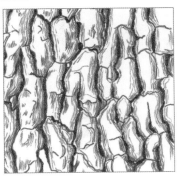

STEP THREE With an HB pencil and rough hatch marks, create lines around the raised areas of bark to suggest layers. This will give the bark a raised appearance.

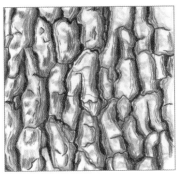

STEP FOUR Use a stump to lightly blend all areas of the bark, leaving the layered lines visible. Then create some darker patches on the bark surface by smudging tone with the graphite already on the stump.

86 Rough Bark in Charcoal

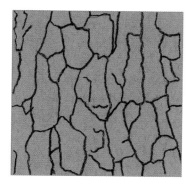

STEP ONE A tan-colored charcoal paper is a good match for drawing bark in charcoal. Use a B charcoal pencil to outline the rough bark. In this example, you can use dark outlines because they will serve as shadows in the final drawing.

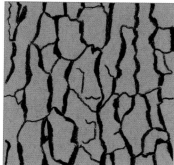

STEP TWO With a 3B charcoal pencil, fill in the areas of shadow in the cracks of the bark to establish the darkest value of the drawing. Keep these dark values irregular in shape.

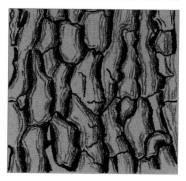

STEP THREE With a sharp 2H charcoal pencil, use light, rough hatch marks around the raised areas of the bark for a layered appearance.

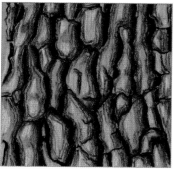

STEP FOUR With a stump, blend lightly to allow the layers to show through. Finish by applying white charcoal pencil to highlight areas of the flat, uppermost surfaces.

87 Pine Needles in Graphite

STEP ONE This example features a small branch from a typical pine tree, such as a ponderosa pine. Begin by creating an outline, with both branches ending in a terminal bud.

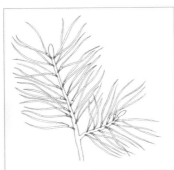

STEP TWO Using a sharp 2H pencil, draw thin needles coming out of the branch. There is a thin, paper-like wrapping at the base where two or more needles sprout outward. Notice how some of the needles are drawn to look as though they are behind some of the others. In your drawing, you can include more needles if desired or as your composition dictates.

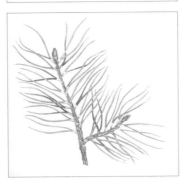

STEP THREE The small branches and terminal buds of a real pine tree appear a bit scaly. To capture this, simply use small groupings of very short hatch marks using a 2B pencil. Now fill in the needles, using HB for the distant and shadowed needles and 2H for near and sunlit needles.

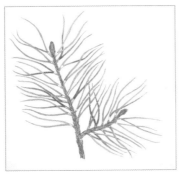

STEP FOUR To finish, use a small tortillon with a sharp tip to very lightly blend all areas of the drawing. Too much blending can diminish the much-needed textures of the branches and buds.

Pinecone in Graphite

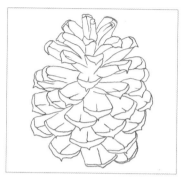

STEP ONE A pinecone is a complex drawing subject, so a good reference photo is important. Use very light strokes to create the outline; the lines shown here are darker for demonstration purposes.

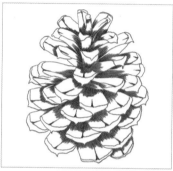

STEP TWO In this example, the darkest shadows will be nearest the core of the pinecone. Use a 4B pencil to stroke outward from the center of the pinecone.

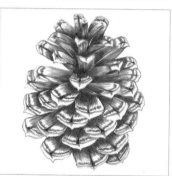

STEP THREE Continue working outward from the 4B areas using an HB pencil. Then use very short strokes to create a line across the end of each pine cone scale. Leave the tips mostly white, toning some areas subtly with a 2H pencil.

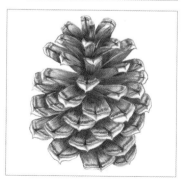

STEP FOUR Now apply some light blending throughout to smooth the texture, allowing some of the pencil strokes to show through.

89 **Palm Frond** in Graphite

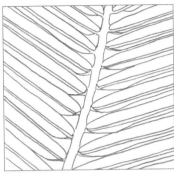

STEP ONE Begin by drawing an outline of the palm frond. Use lines that are much lighter than shown here, which will prevent any hard lines from showing through in the finished drawing.

STEP TWO Identify the darkest value first, which includes the most shadowed areas of the plant. Use a 4B to fill in these areas on each leaf of the frond.

STEP THREE Use an HB for the next darkest value, followed by a 2H for the lightest values on the leaves and stem. Use long, parallel strokes on the leaves to represent the veins.

STEP FOUR To finish, lightly blend the leaves and stem with a stump or tortillon for a smoother finish.

Thatched Roof in Graphite

STEP ONE Begin this thatched roof by marking the edge of each layer.

STEP TWO Using the light lines of an HB pencil, indicate strands of layered thatch. The lines should follow the same general direction, but they should not be perfectly parallel to each other for a more realistic look.

STEP THREE Using a 2B pencil, create dark, uneven areas of shadow along the ends of the layers, creating depth and contrast.

STEP FOUR Using a stump with graphite embedded into the surface, blend slightly as you add light tone to areas of the thatch, creating even more depth.

91 **Fern** in **Graphite**

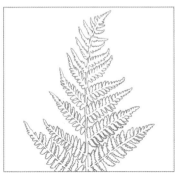

STEP ONE Begin by drawing the basic outline of the fern. Use light strokes for this step; the lines shown here are darker for demonstration purposes.

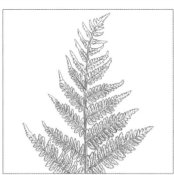

STEP TWO With a sharp-tipped HB pencil, draw the veins in the small, individual fern leaves, as well as a line representing the main stem. On this type of fern, the main stem is concave and runs down the length of it, which you can represent with a thick line down the center.

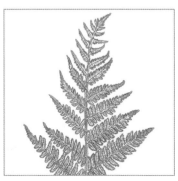

STEP THREE With a 2H pencil, fill in around the very edges of the individual leaves, avoiding the previously drawn veins. Fill in the leaves toward the tips of each branch.

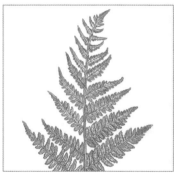

STEP FOUR To finish, use a fine- or sharp-tipped tortillon or stump to blend around the edges of the leaves (where you applied the 2H). Leave some of the veins and leaf centers light. To finish, lightly blend the stems.

92 | MOSS in Graphite

STEP ONE This example features rock cap moss, which grows on rocks and boulders in shady, humid conditions. Begin with a light outline; the lines shown here are darker for demonstration purposes.

STEP TWO Using a 4B pencil, draw thin, rough, jagged areas of shadow along the sides of the moss.

STEP THREE Switching to an HB pencil, apply tiny, loose, overlapping strokes to create the texture of the moss. Allow some white of the paper to show through these strokes for more contrast in the texture. To give the moss more form, create darker areas by applying your strokes closely. Then stipple to suggest the tiny areas of shadow.

STEP FOUR To finish, very lightly blend the moss, being careful not to blend out the texture of your overlapping strokes.

93 **Grass** in Graphite

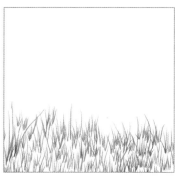

STEP ONE This example is one of many methods you can use to draw grass. This subject is a bit of a challenge, and it may take some practice to produce convincing results. Begin with a sharp 4B pencil and draw blades of grass, stroking upward and tapering the tips. Place clumps of grass randomly, and avoid placing them in a straight line. Curve each blade as you stroke, allow some to cross over each other, and vary the lengths of your strokes for a realistic touch.

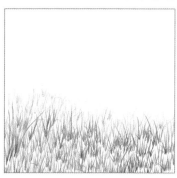

STEP TWO To give the grass contrast and depth, use sharp HB and 2H pencils to thicken the grass with more tapered strokes throughout. Add light blades above your original strokes to suggest grass that fades into the distance.

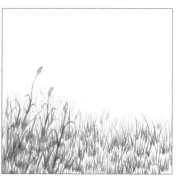

STEP THREE With the 4B pencil, create a few seed-tipped stalks of grass and add random longer, darker blades where needed. To create the seed tips, apply very short strokes that angle slightly outward.

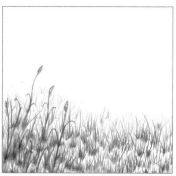

STEP FOUR To finish, use a small tortillon to lightly blend the bottom of most of the clumps, giving the drawing even more contrast and depth.

Smooth Rock in Graphite

STEP ONE Drawing smooth rock is a simple process. Begin by drawing a light outline using various oval shapes; the lines shown here are darker for demonstration purposes.

STEP TWO Use a 4B pencil to establish the darkest value first, which is in the deepest areas between the rocks. Then use a 2B and overlapping circular strokes to draw outward from the 4B areas, creating a smooth gradation for a three-dimensional appearance.

STEP THREE With an HB and looser, overlapping circular strokes, create the next darkest values of the rocks. Then switch to use a 2H to build the lightest areas. These loose, circular strokes will create a realistic texture on the surface of the smooth rocks.

STEP FOUR To finish, lightly blend with a stump, allowing some of the strokes to show through for a realistic touch.

95 **Mountain Rock** in Graphite

STEP ONE Draw the basic outline of the jagged mountain rock, including the larger shadowed areas. Use light lines for this step; the lines shown here are darker for demonstration purposes.

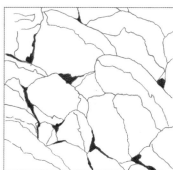

STEP TWO Use a 4B pencil to fill in the darkest values, which are the small areas of deep shadow between the rocks.

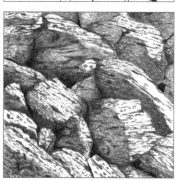

STEP THREE Use 2B and HB pencils to create linear cracks and stippling on the surface of the rocks, including areas in light shadow. With the HB pencil and loose, overlapping circular strokes, create the lightest shadows. This will give the rocks a rough, textured look even after lightly blending.

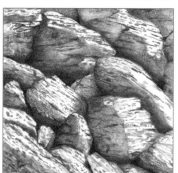

STEP FOUR To finish, lightly blend all the areas of shadow. Allow some of the circular strokes to show through to maintain the rough texture. To lighten areas if needed, simply dab away tone with the kneaded eraser.

Mountain Rock in Charcoal

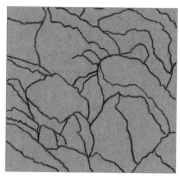

STEP ONE To begin, draw an outline of a hillside of mountain rock using very light lines over toned paper. (The lines shown here are darker for demonstration purposes.) Use either a 2H graphite pencil or a 2H charcoal pencil with light pressure. If needed, outline some areas of light and shadow.

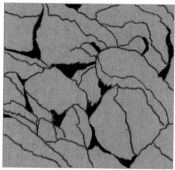

STEP TWO Using a 3B charcoal pencil, create some of the darkest shadows in between the deepest areas of the individual rocks.

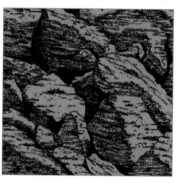

STEP THREE Use long strokes and an HB pencil to create lighter areas of shadow. When applied over charcoal paper, the surface texture adds to the rough look. Still using the HB, add lines and stippling on the highlighted areas of the rocks for more detail.

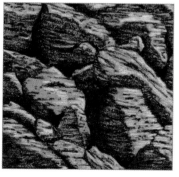

STEP FOUR Lightly blend the areas of shadow. To finish, use a white charcoal pencil to add highlights for depth and contrast.

97 **Seashell** in Graphite

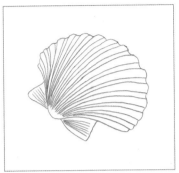

STEP ONE This example shows a common scallop seashell. Begin by creating a light outline of the shell; the lines shown here are darker for demonstration purposes.

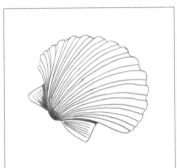

STEP TWO Use a 2B pencil to establish the darkest values within the scene.

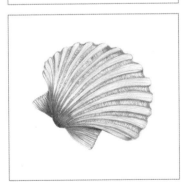

STEP THREE Switch to a 2H pencil to tone the raised ribbed areas using long strokes that follow their natural curves. Between the ribs, draw small, curved lines using an HB pencil, which suggests the concave nature of the structure.

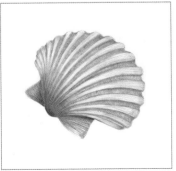

STEP FOUR To finish, blend very lightly and be sure to retain some of the lines from Step Three.

Running Water in Graphite

STEP ONE Running water can be very difficult to draw due to the variety of shapes and values involved. When drawing this subject in graphite, it is helpful to simplify a reference photo by converting it to grayscale, removing the distraction of color. Begin by outlining the various shapes that make up the water's surface.

STEP TWO Use a 4B pencil to place the darkest values first, which will help you determine where other values belong. Note: Like most graphite drawings in this book, this example uses 4B, 2B, HB, and 2H pencils. Remember that each pencil grade can yield several different values, depending on the pressure applied while drawing.

STEP THREE For the remainder of the drawing, use 2B, HB, and 2H pencils to build the various values throughout. Leave some areas of the paper white to represent the lightest reflections.

STEP FOUR To finish, lightly blend all areas with a tortillon, except for the white of the paper that remains. Add lighter values throughout for more depth and variety by applying tone with the tortillon as you work.

99 **Clouds** in Graphite

STEP ONE This example features one of many methods for drawing common cumulus clouds. These plump, beautiful clouds are great for adding interest to a drawing. In this method, you will simply use a stump, graphite powder (saved from pencil shavings), tissue, and a click pencil eraser. Begin by dipping a folded tissue into graphite powder and rubbing over the paper. Create a smooth sky on top and darker clouds below.

STEP TWO Using the click pencil eraser, create a sharp outline of the edge of the clouds. As you erase, use a circular motion to produce a bumpy appearance.

STEP THREE Next use an old, blunt stump to apply graphite over the cloud shadows. As the shadows lighten, apply increasingly less pressure. Then use the click pencil eraser again to create sharp cloud edges.

STEP FOUR Use the stump to reapply graphite to create darker areas of the clouds, if needed for more contrast. Then use the sharply cut tip of a pencil eraser to work around the bright edges, giving the clouds a wispy appearance. Also, use this eraser to create linear clouds and small puffs for realism and interest.

Raindrops on Water in Graphite

STEP ONE When viewed from above, raindrops on water create circles; when viewed from any other angle (such as from the shore), they look elliptical. To begin this subject, draw different sizes of ellipses.

STEP TWO When raindrops hit the water, they create waves that move out from the center. To re-create this example, draw two small ripples around each original ellipse.

STEP THREE To create the illusion of depth in the waves, use a 2B pencil to draw tapered shadows around the waves. Notice that the shadows closest to the viewer appear on the outside of the wave, and the shadows farthest away are on the inside. Replicating this will give the waves a three-dimensional quality. Add smaller waves on the sides of each raindrop. Notice the diamond shapes that are created by the waves intersecting.

STEP FOUR To finish, use well-used stump with a dull tip to apply tone around and inside each raindrop, creating subtle waves and giving a light value to the water's surface. To reload the stump with graphite, simply dip the tip into graphite powder and strokes over a separate sheet of paper until you reach the desired value.

101 **Raindrops on a Window** in Graphite

STEP ONE Begin by drawing the shapes of your raindrops using light lines. (The lines shown here are darker for demonstration purposes.) For a realistic look, vary the sizes and shapes of your raindrops, and allow one or more to appear as though it has run down the window, leaving a trail of water.

STEP TWO Raindrops act like tiny lenses and reflect both background values and surrounding light, creating a variety of values within the drops. To replicate this example, apply the darkest values to the upper parts of each raindrop using a 2B. Add value to the side of the water trail as well.

STEP THREE To give the water more depth, use a small tortillon to blend the inside of each drop and along the trail of water. The small amount of graphite on the tortillon will help you apply lighter values within your drops, yielding more depth and dimension.

STEP FOUR To finish, use a click pencil eraser to remove a tiny portion of the outline from the left side of each drop and the water trail, suggesting light reflecting through the water.

ARTIST'S GALLERY

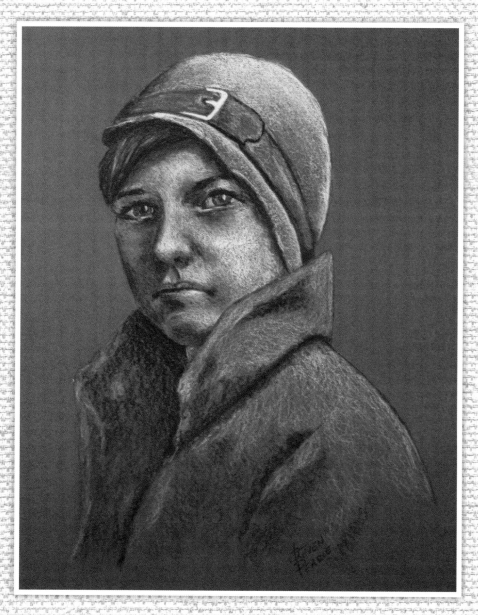

20s Girl
Charcoal on toned paper with white highlights yields a portrait with dramatic lighting. For more on drawing people, see Chapter 1. For more on drawing fabrics, see Chapter 3.

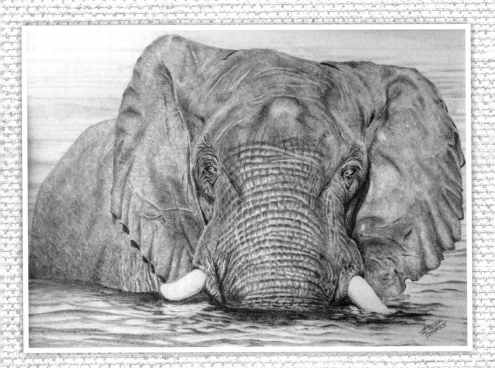

▲ Young Elephant
Graphite allows for a dynamic combination of smooth tones and detailed strokes. Erasers can effectively pull out tone in thin lines, creating realistic highlights and creases, as shown on this elephant's skin. For more on drawing elephants, see page 40.

◄ Young Lion
The smooth, wispy tones of blended graphite are an effective match for the fluffy fur of a young lion. For more on drawing felines, see pages 34–36.

125

Wine on the Deck
The rough, grainy feel of wooden planks and the smooth, reflective nature of glass create interesting contrasts. The curves of the glass against the straight lines of the wood further separate these elements.

For more on drawing wood, see pages 76–81. For more on drawing glass, see page 89.

About the Artist

Like many artists, Steven Pearce got his start at a very early age. His mother was an accomplished oil painter, and his father was an oil painter, sculptor, and master jeweler. Their encouragement and valuable knowledge helped Steven grow as an artist. Creating art with a pencil has been and continues to be a passion of Steven's, and is always at the forefront of the mediums he uses. He enjoys experimenting with other media, including colored pencil, oil, and acrylics. Steven loves drawing portraits, still life, wildlife, landscapes, and anything that represents well in graphite and charcoal. Learn more at www.stevenpearceart.com.